THIS COLORING BOOK BELONGS TO

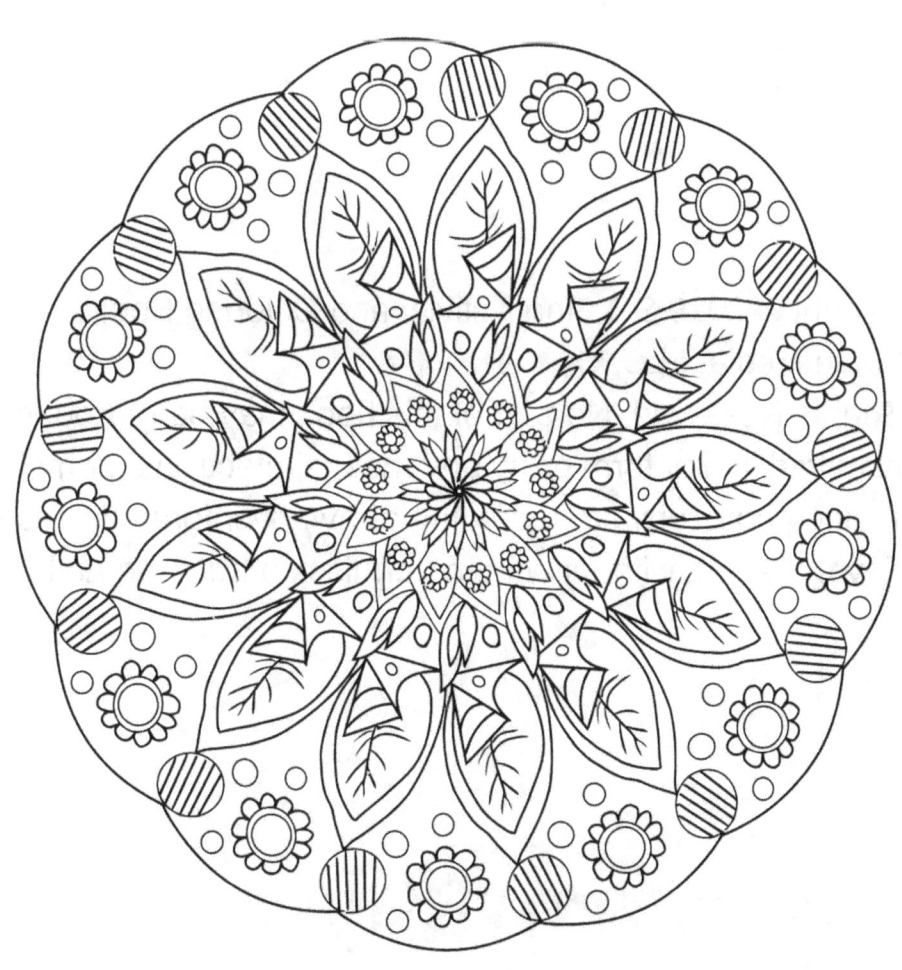

Copyright © 2019 SO Fine Activity and Coloring Books
SO Fine Media, LLC.
All Rights Reserved. No part of this book may be reproduced or transmitted in any form or by any means, electronic or mechanical, including photocopying, recording or by any information storage and retrieval system, without written permission from the author.

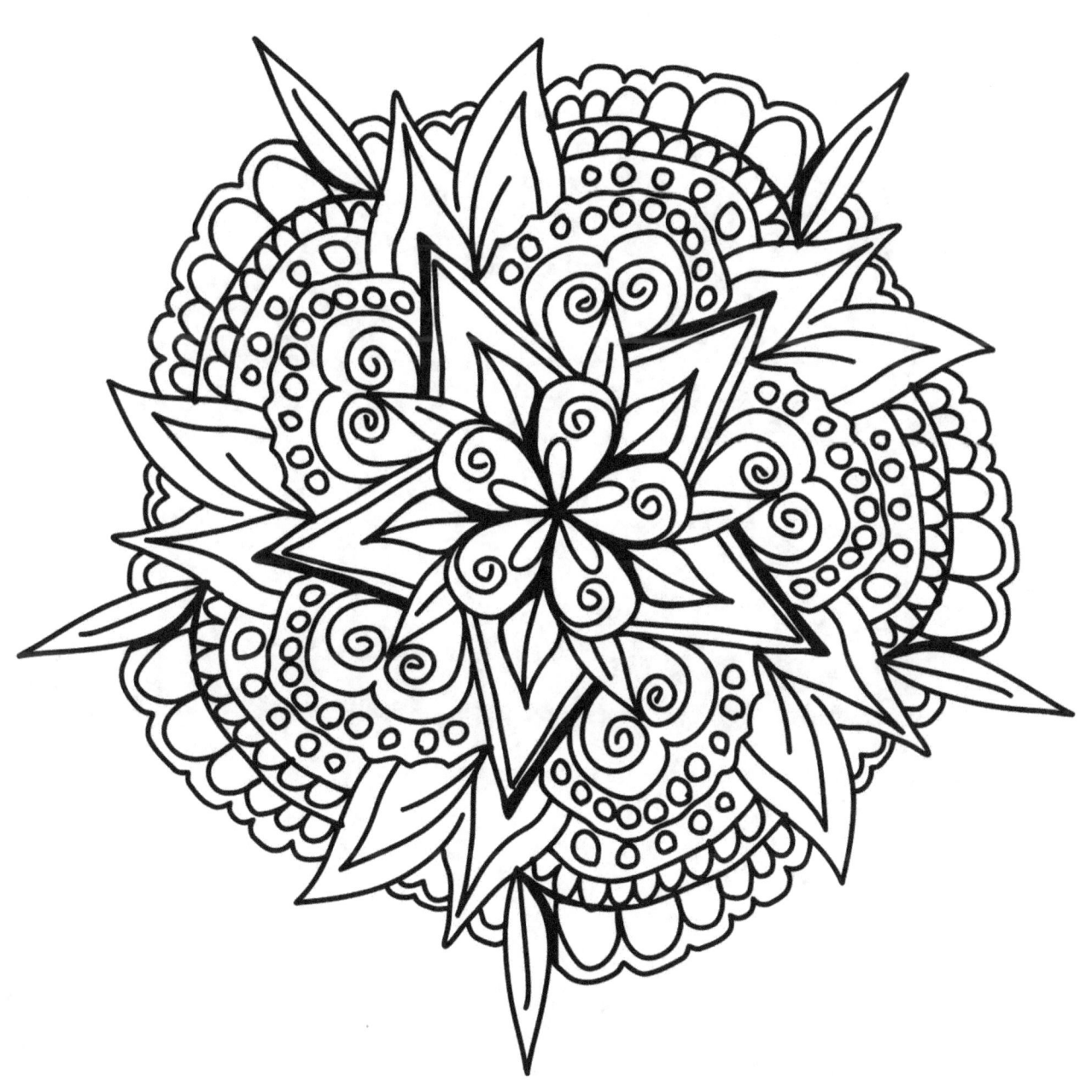

Mandalas are Relaxing

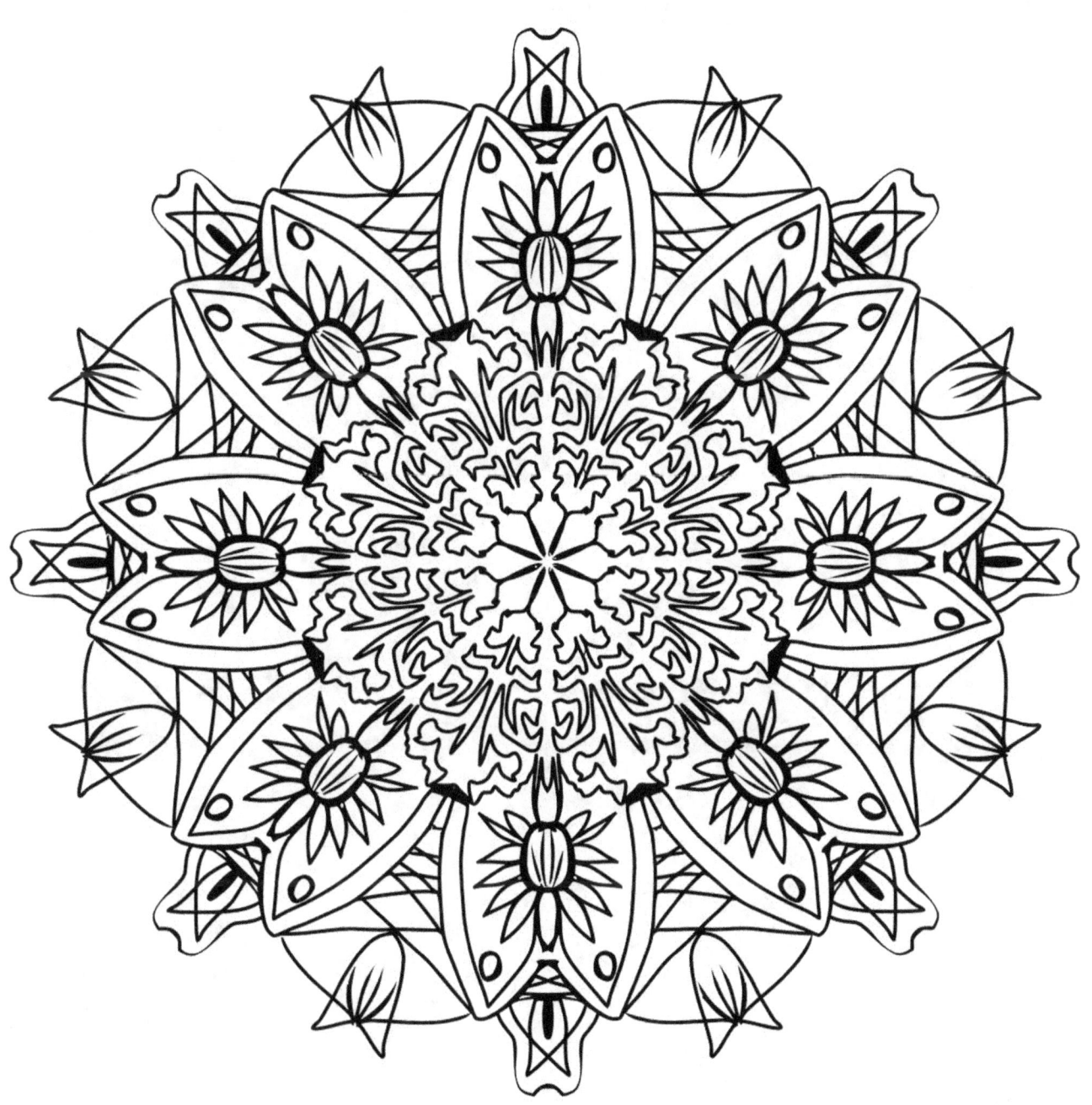

Mandalas are Relaxing

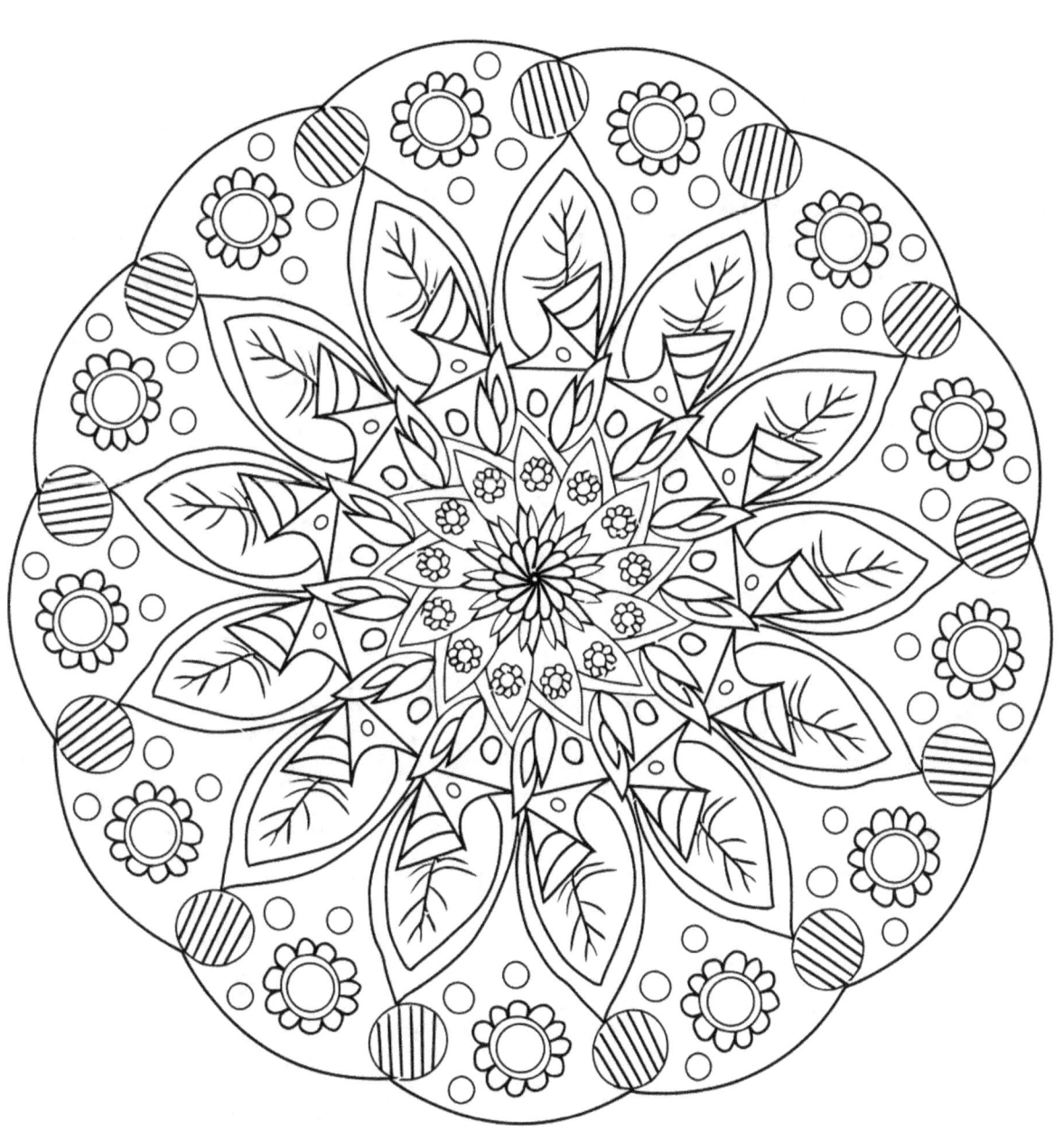

Mandalas are Relaxing

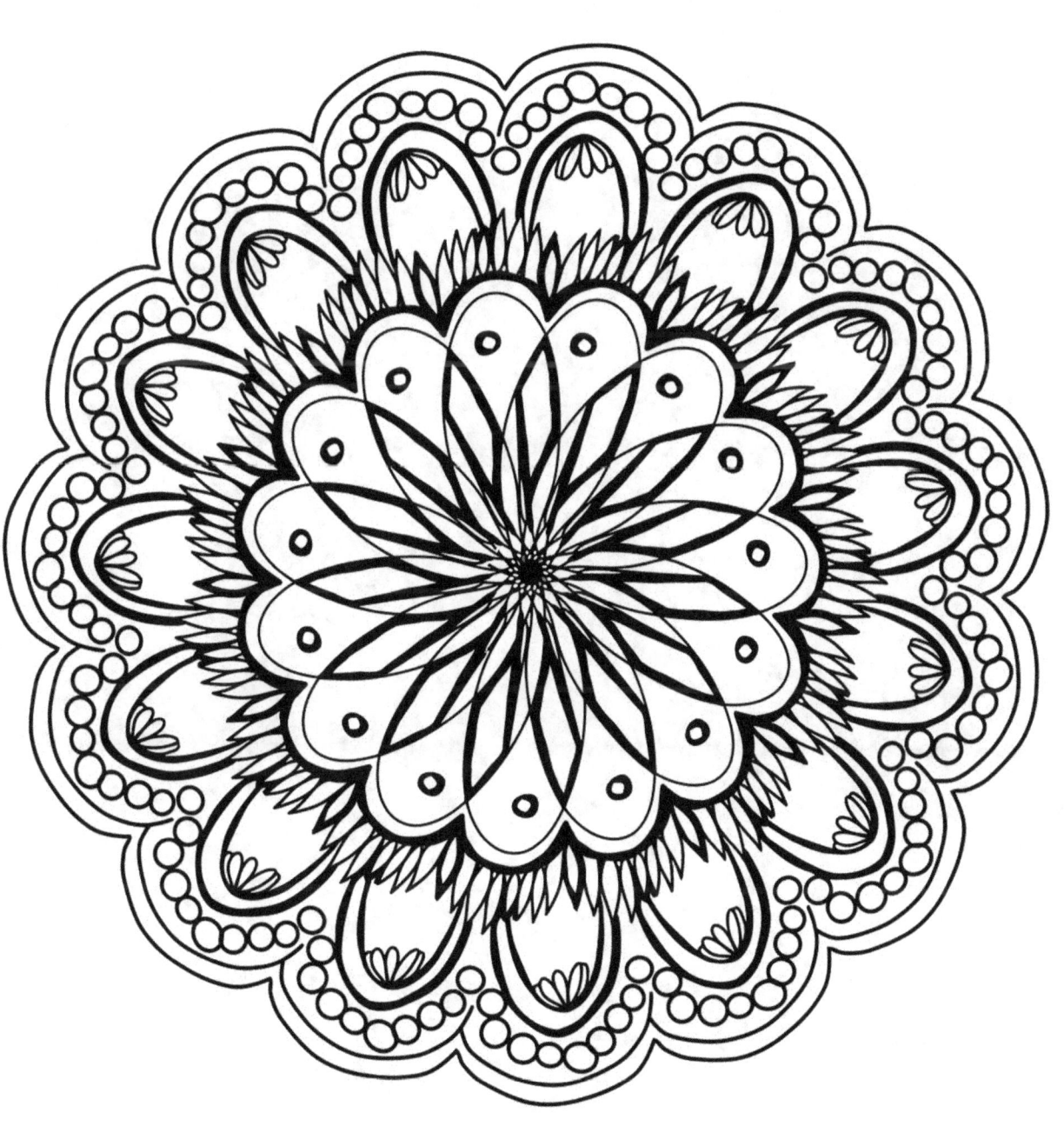

Mandalas are Relaxing

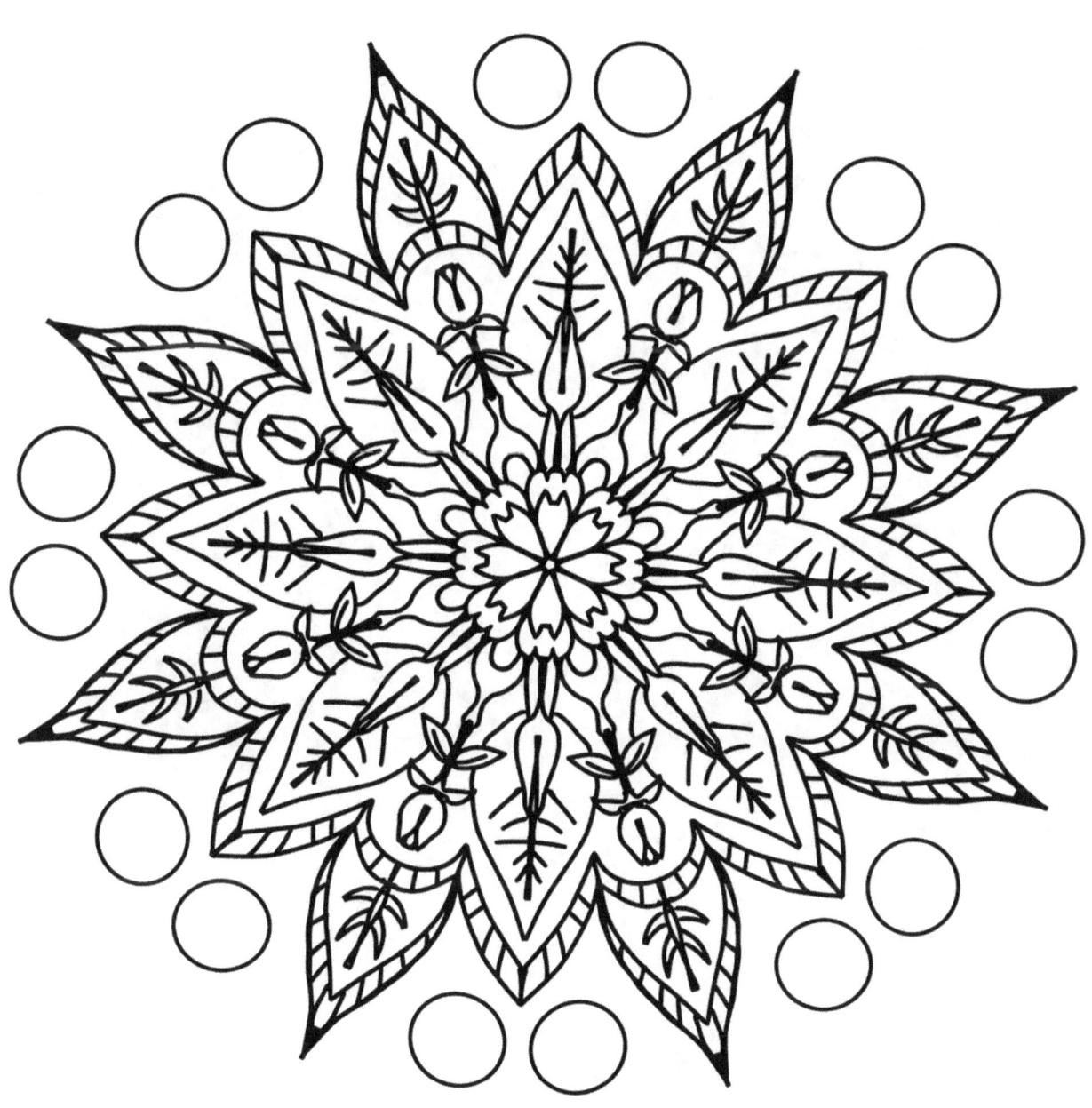

Mandalas are Relaxing

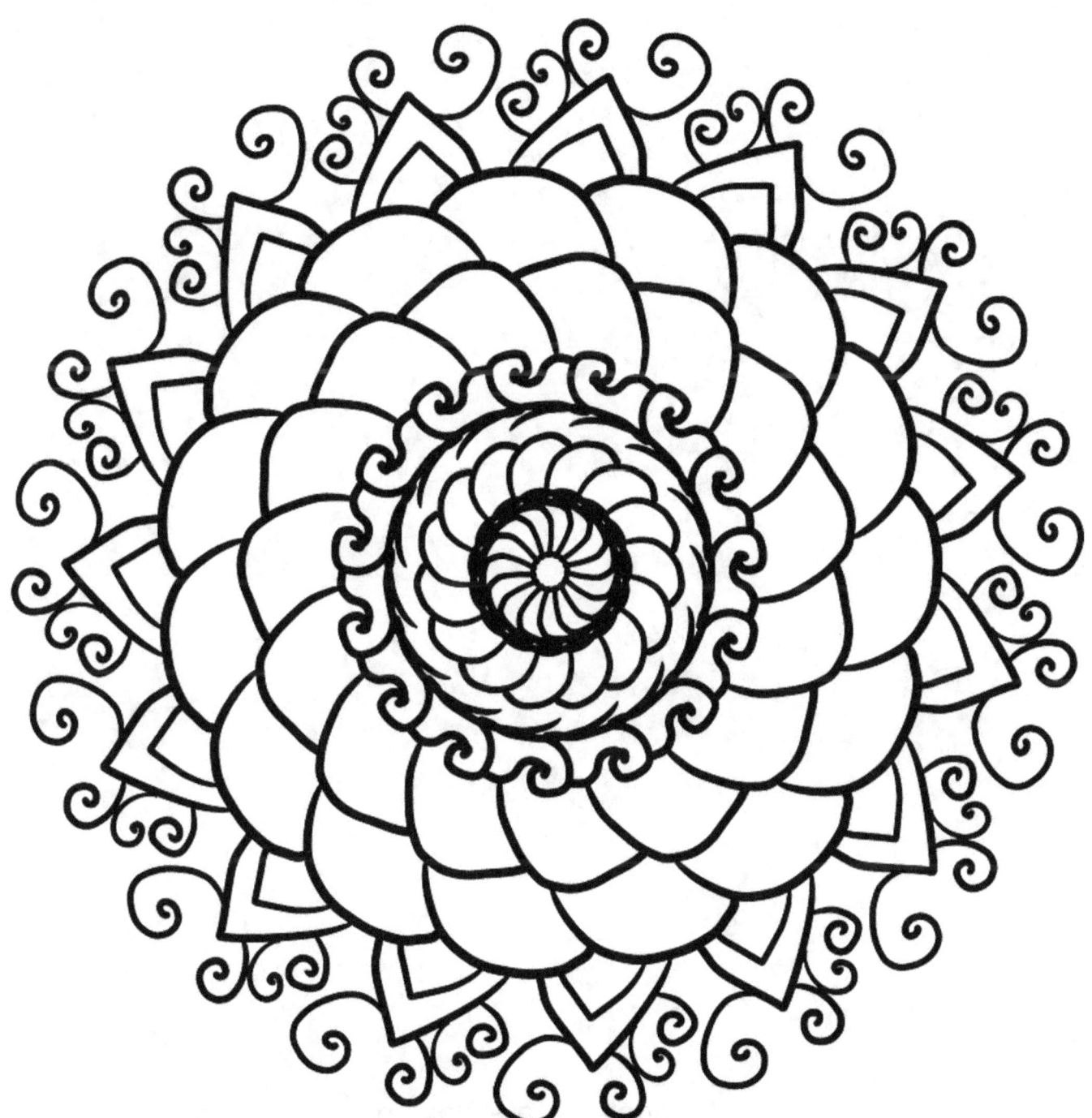

Mandalas are Relaxing

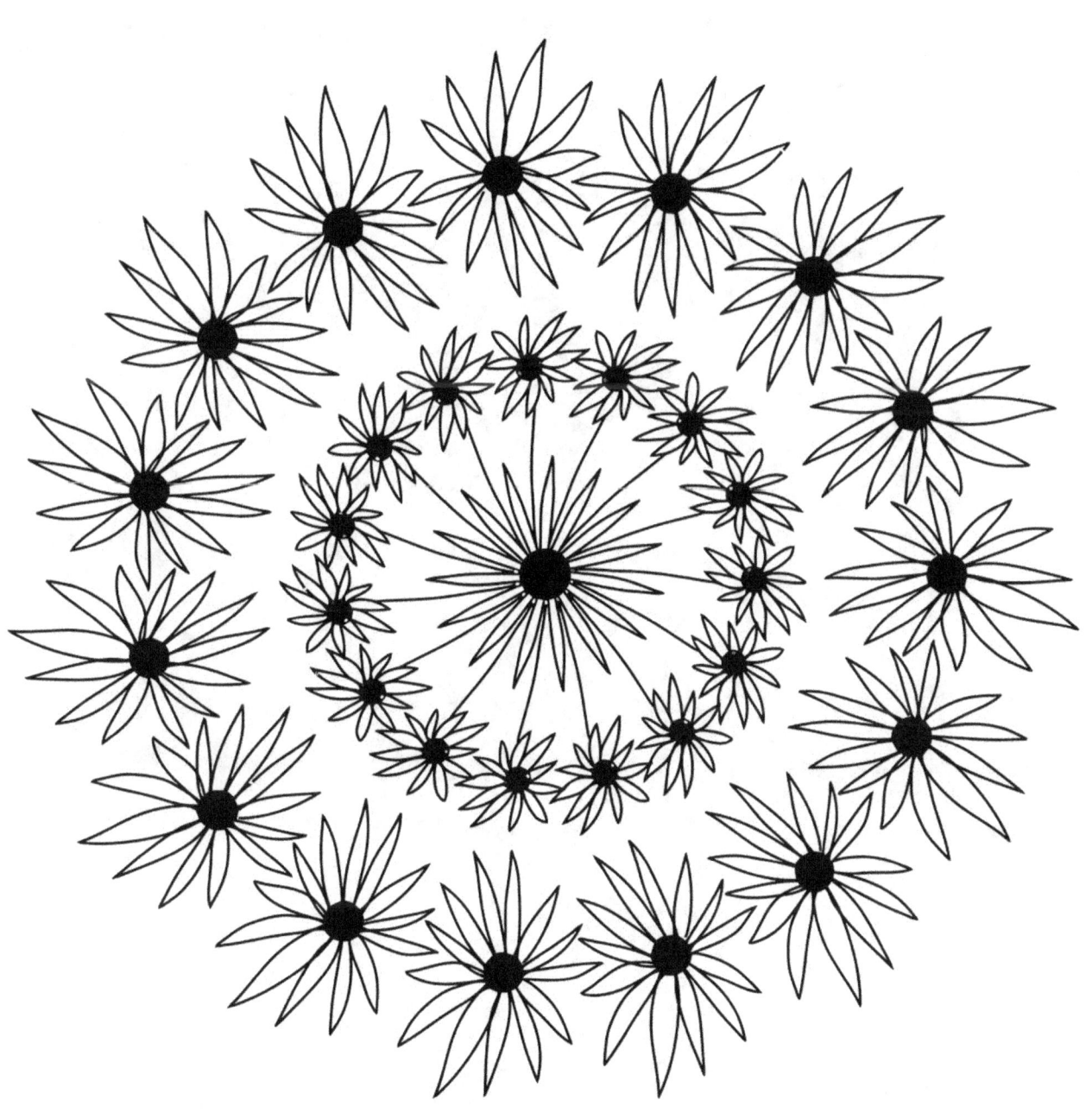

Mandalas are Relaxing

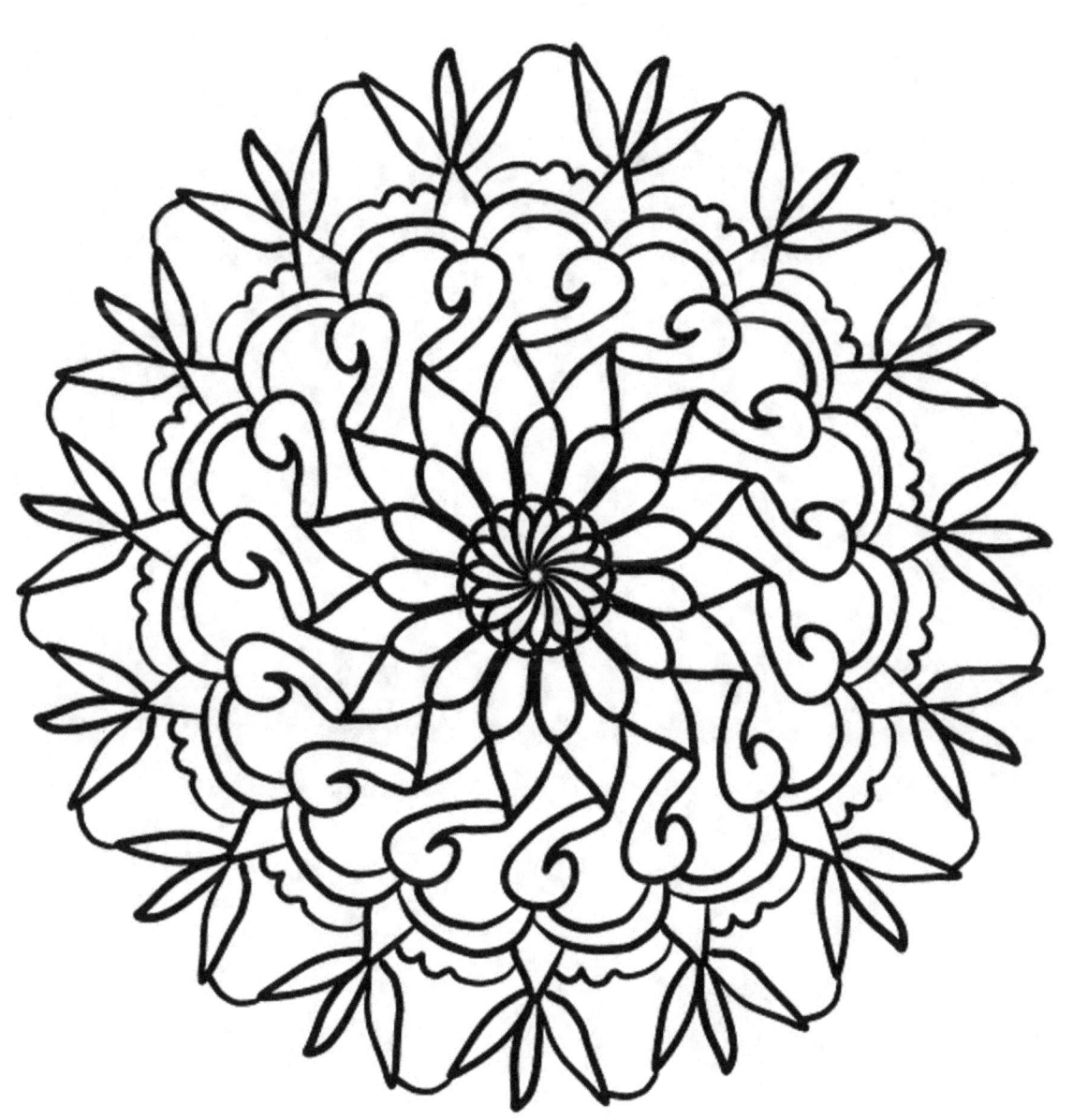

Mandalas are Relaxing

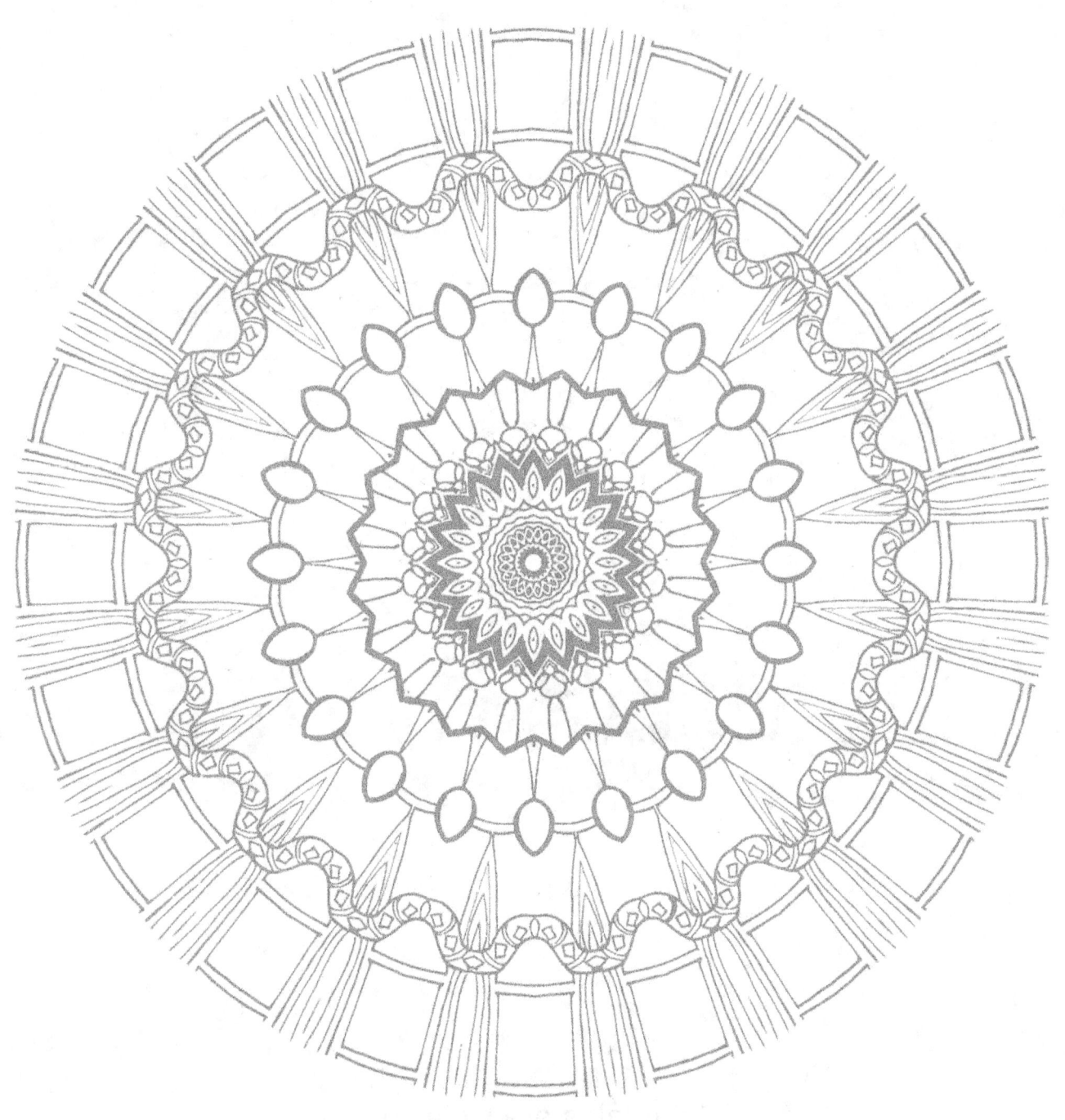

Mandalas are Relaxing

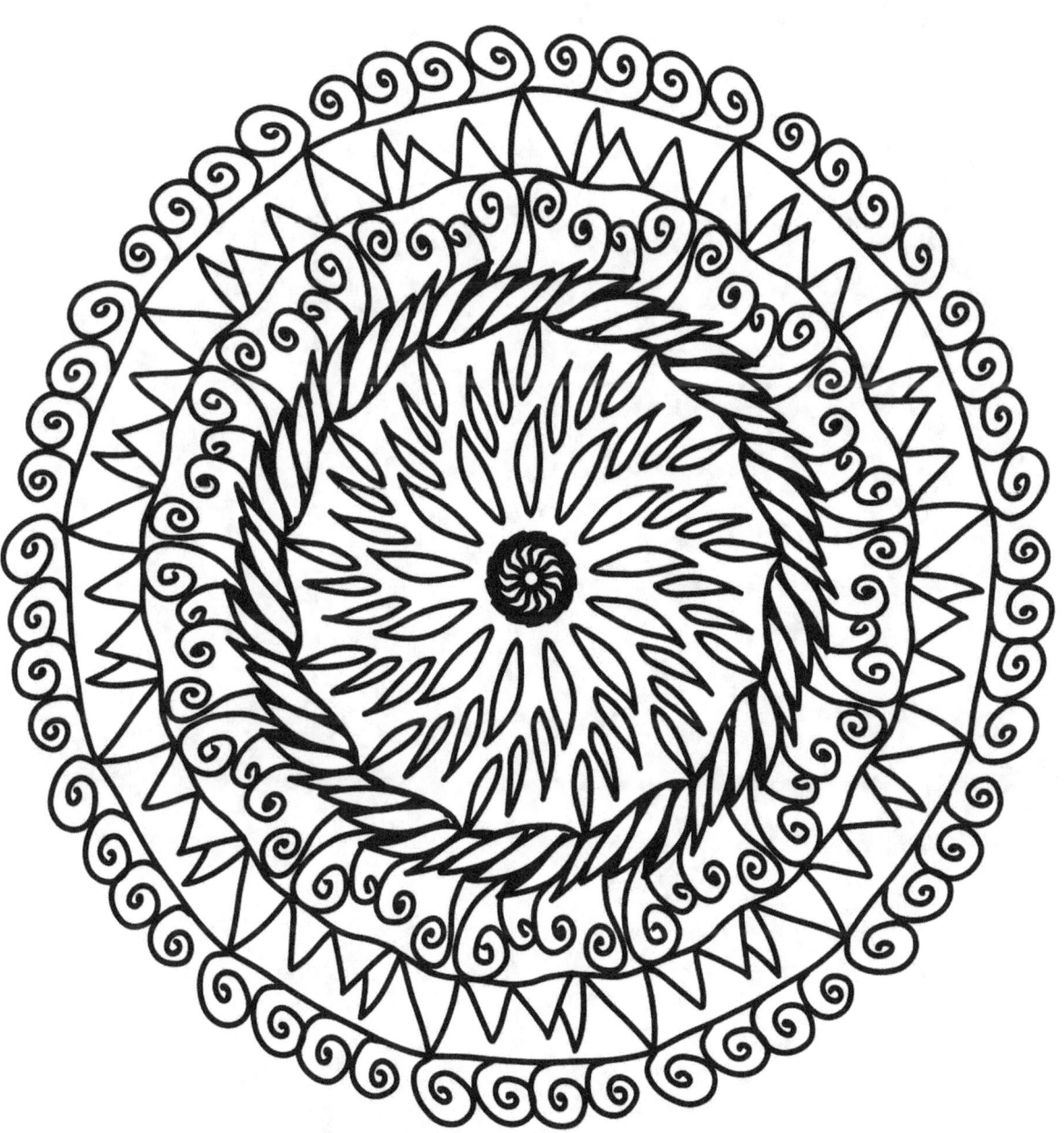

Mandalas are Relaxing

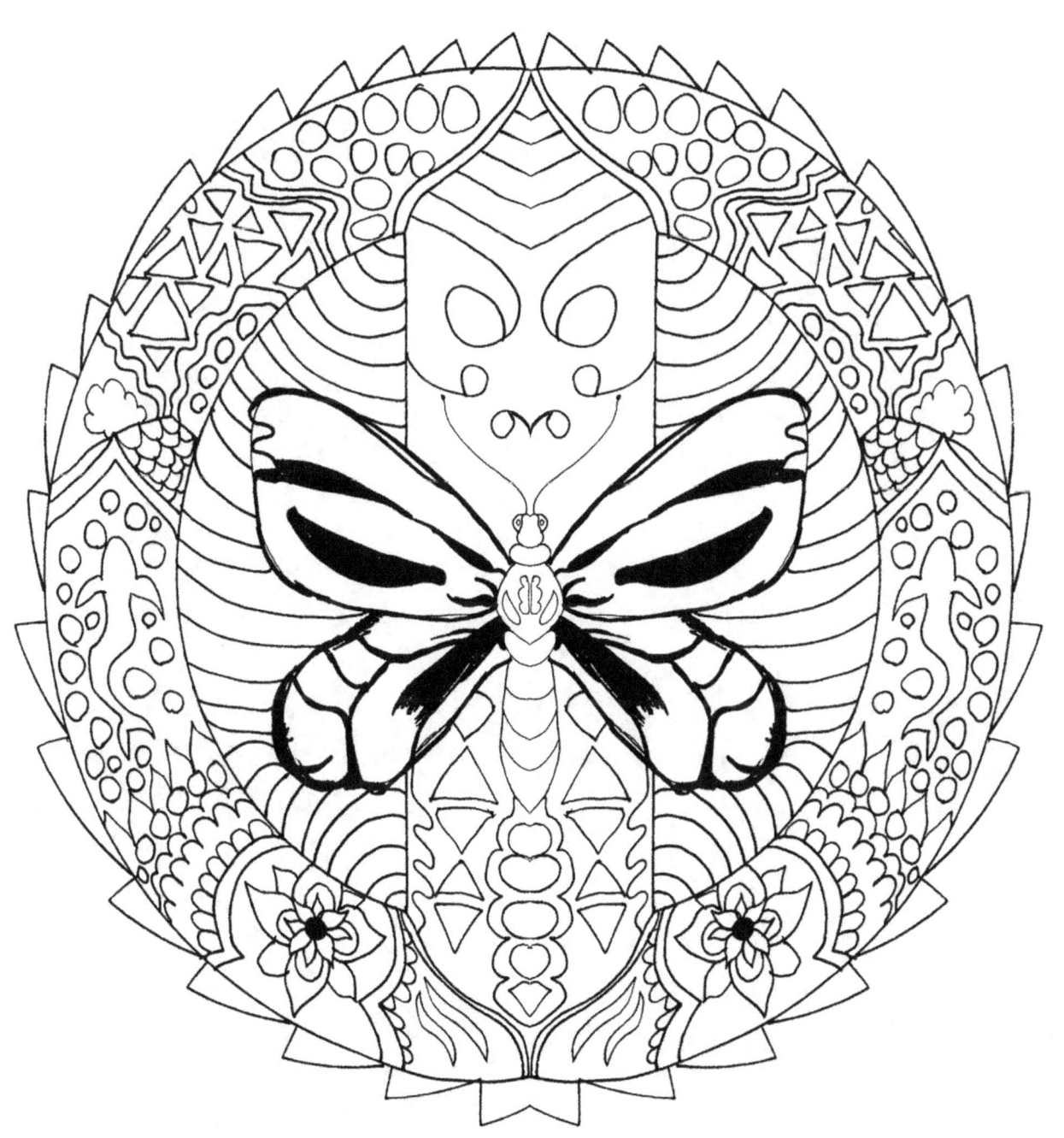

Mandalas are Relaxing

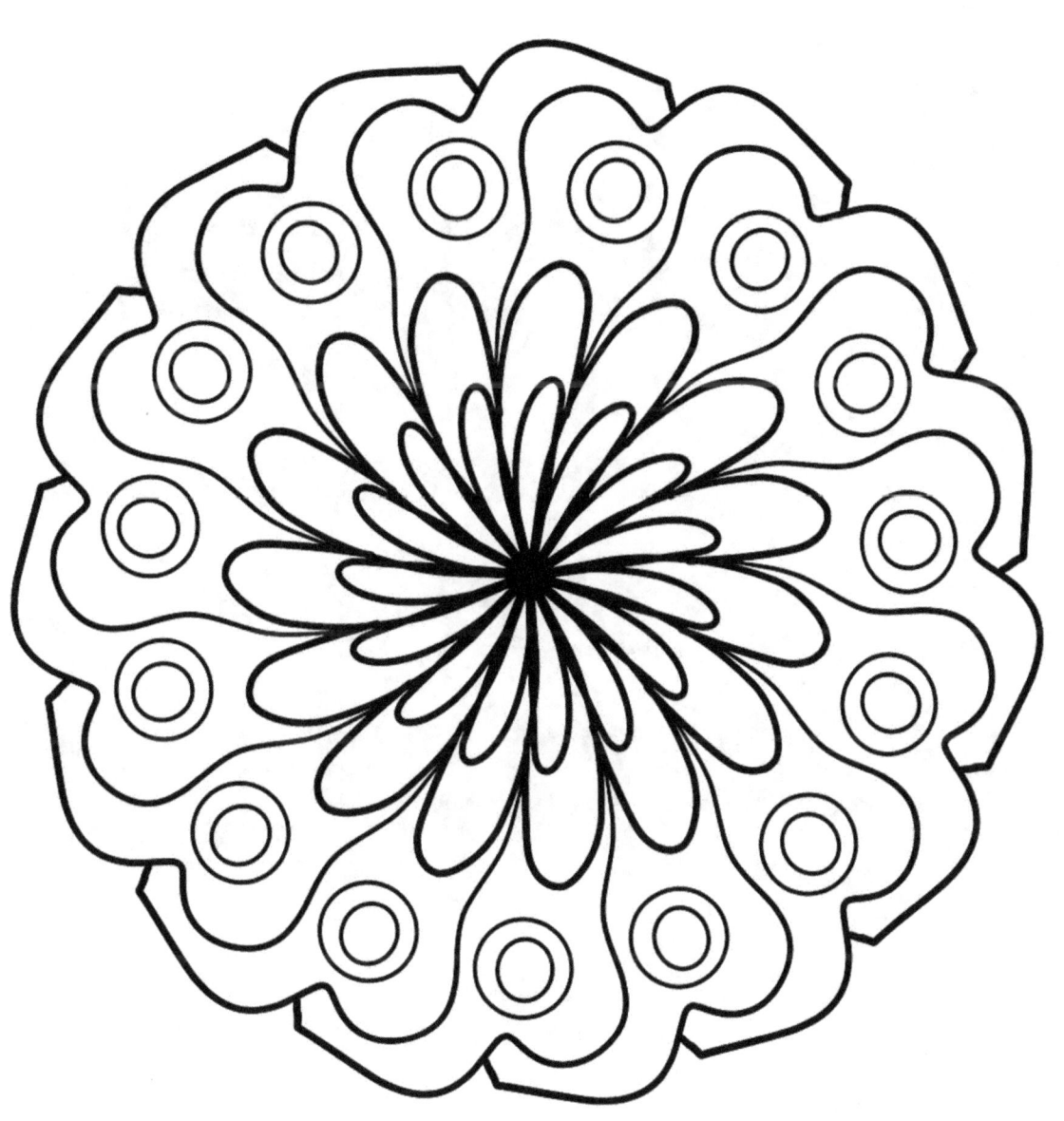

Mandalas are Relaxing

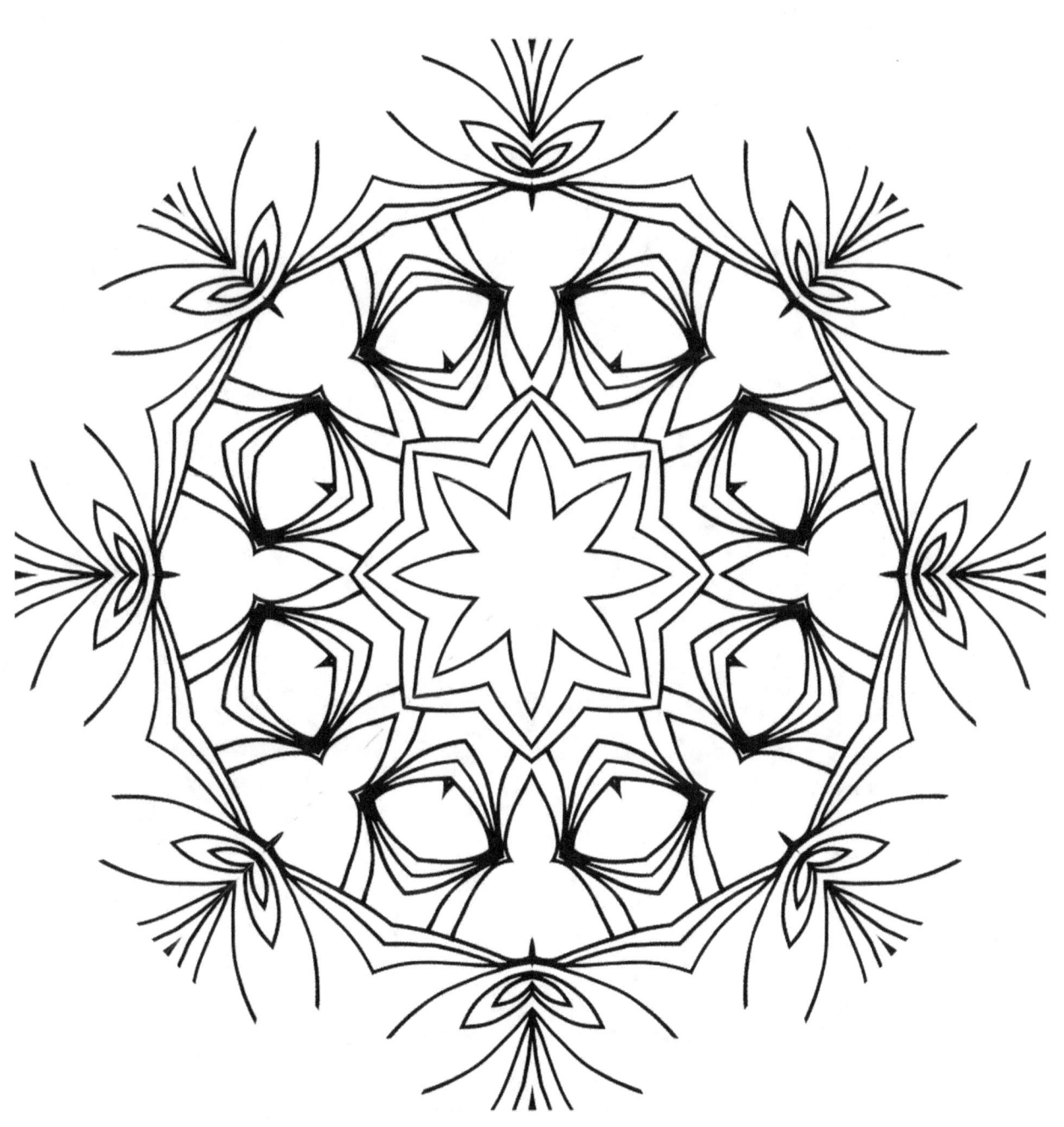

Mandalas are Relaxing

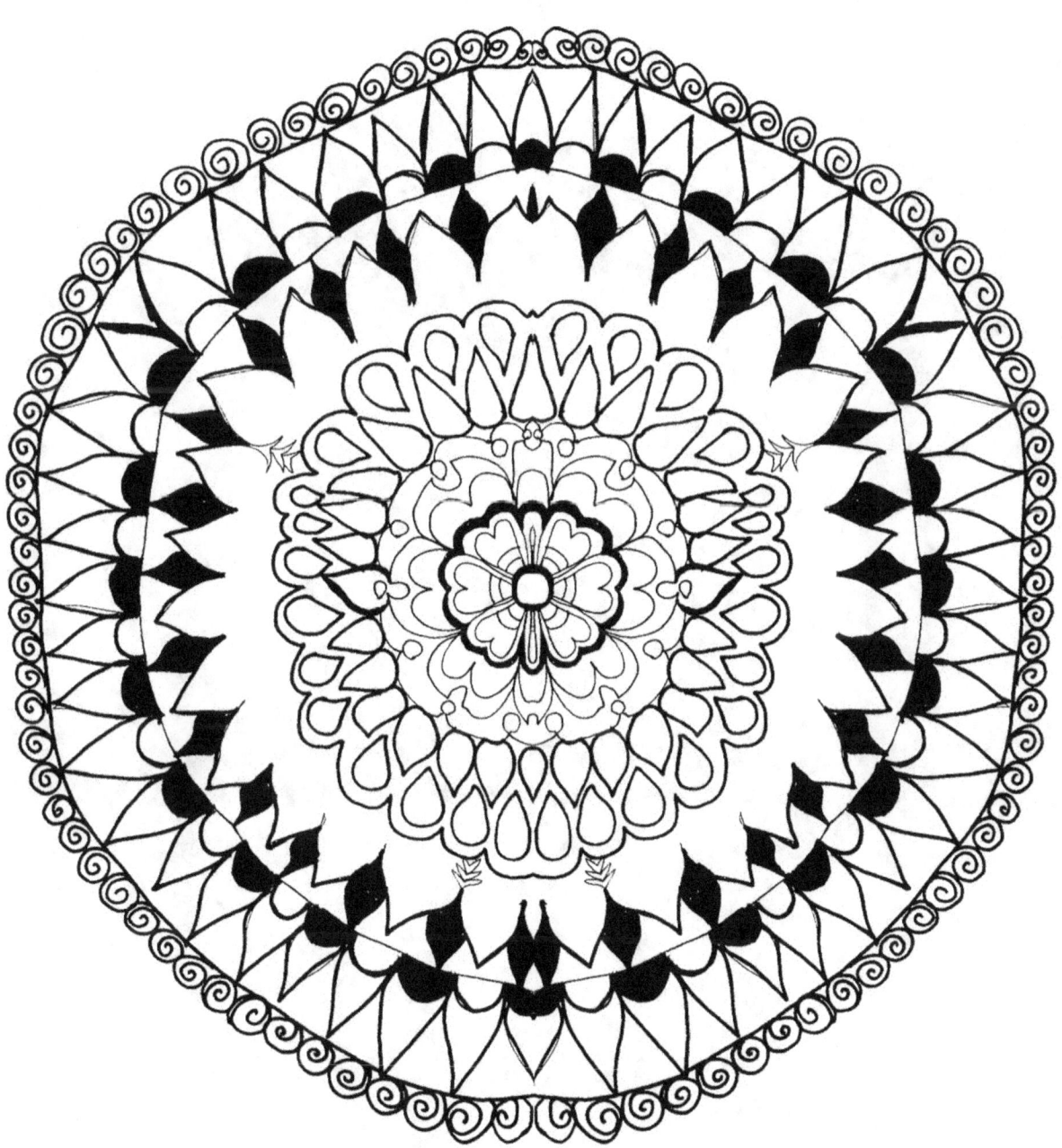

Mandalas are Relaxing

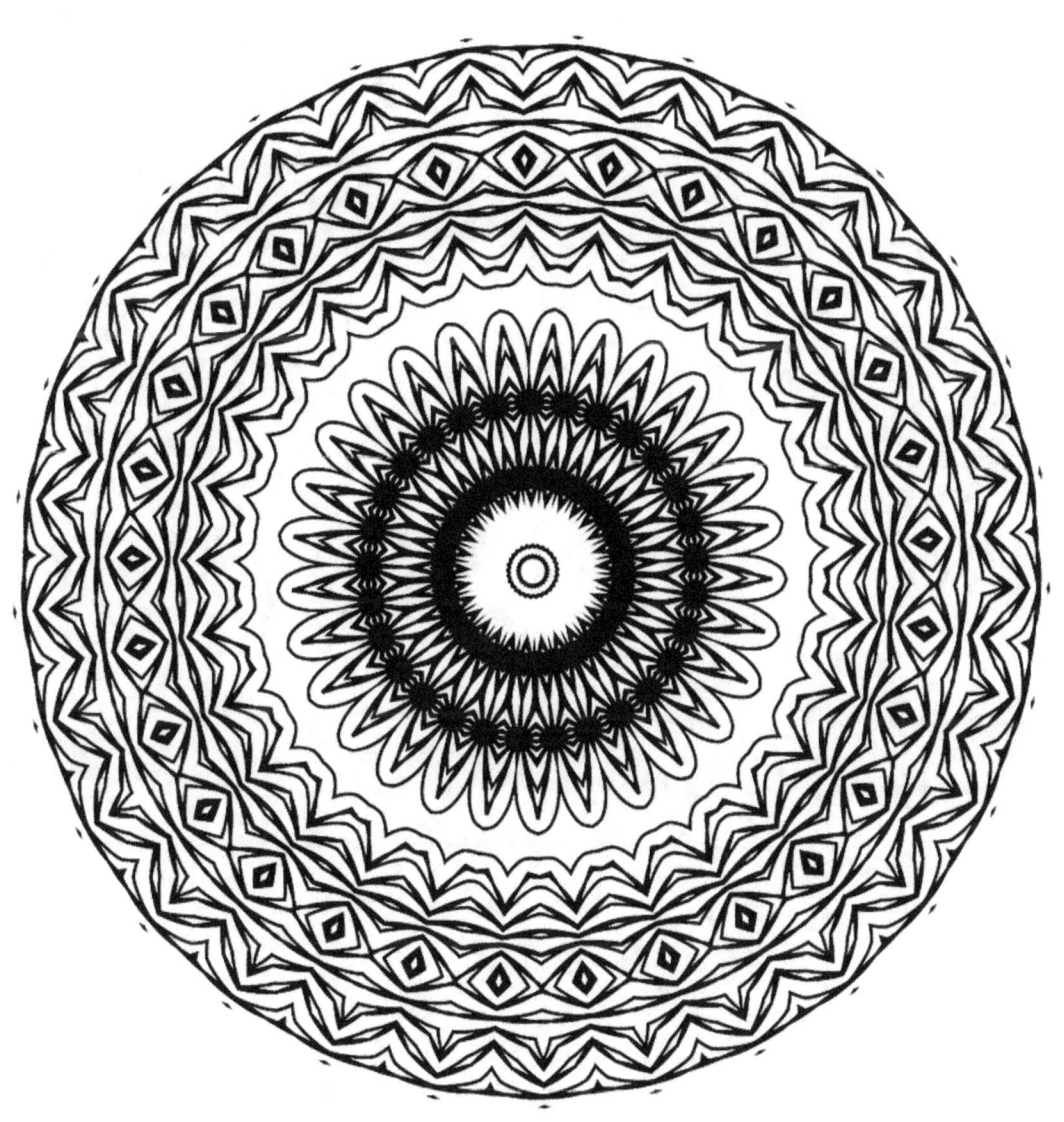

Mandalas are Relaxing

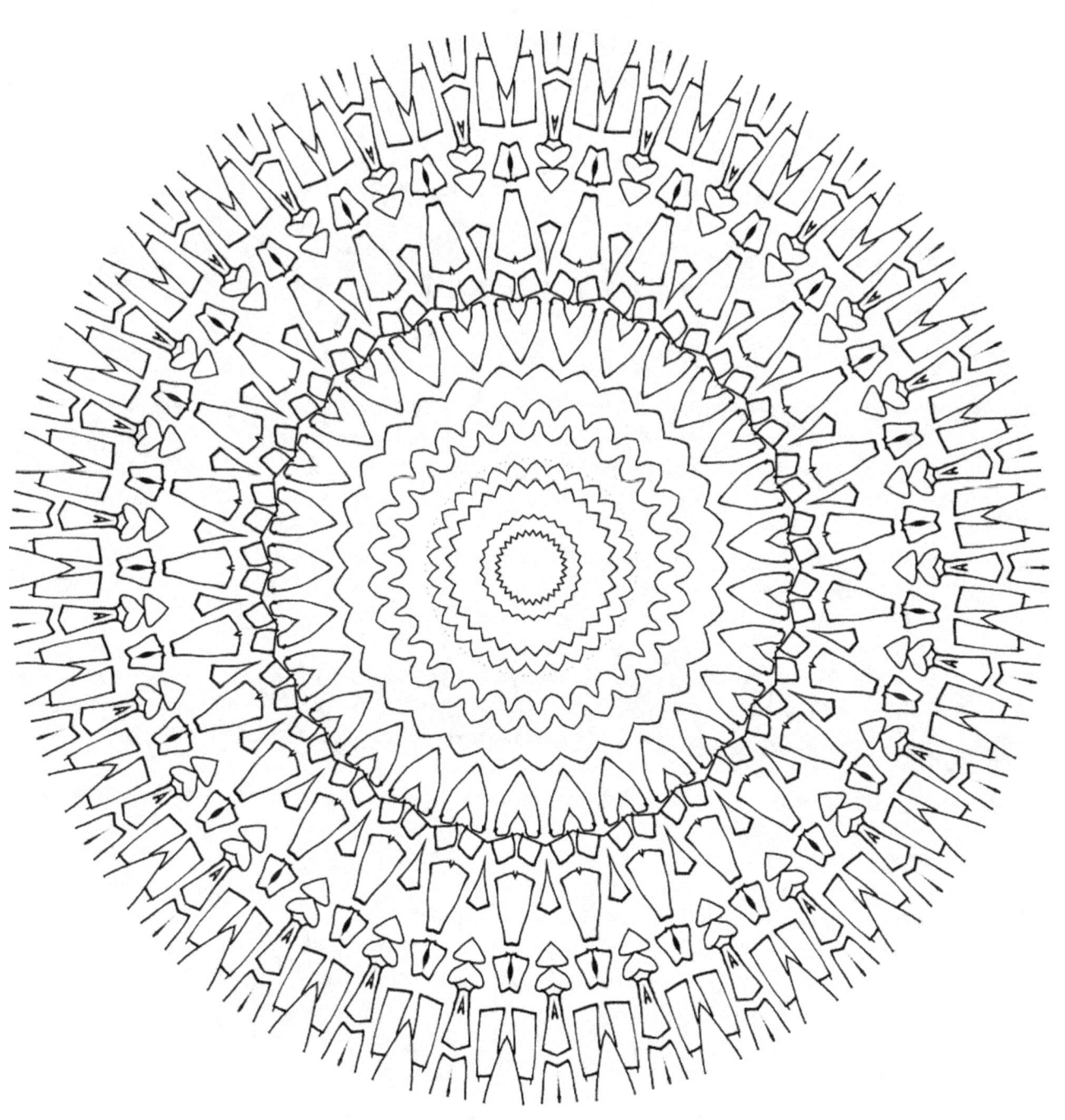

Mandalas are Relaxing

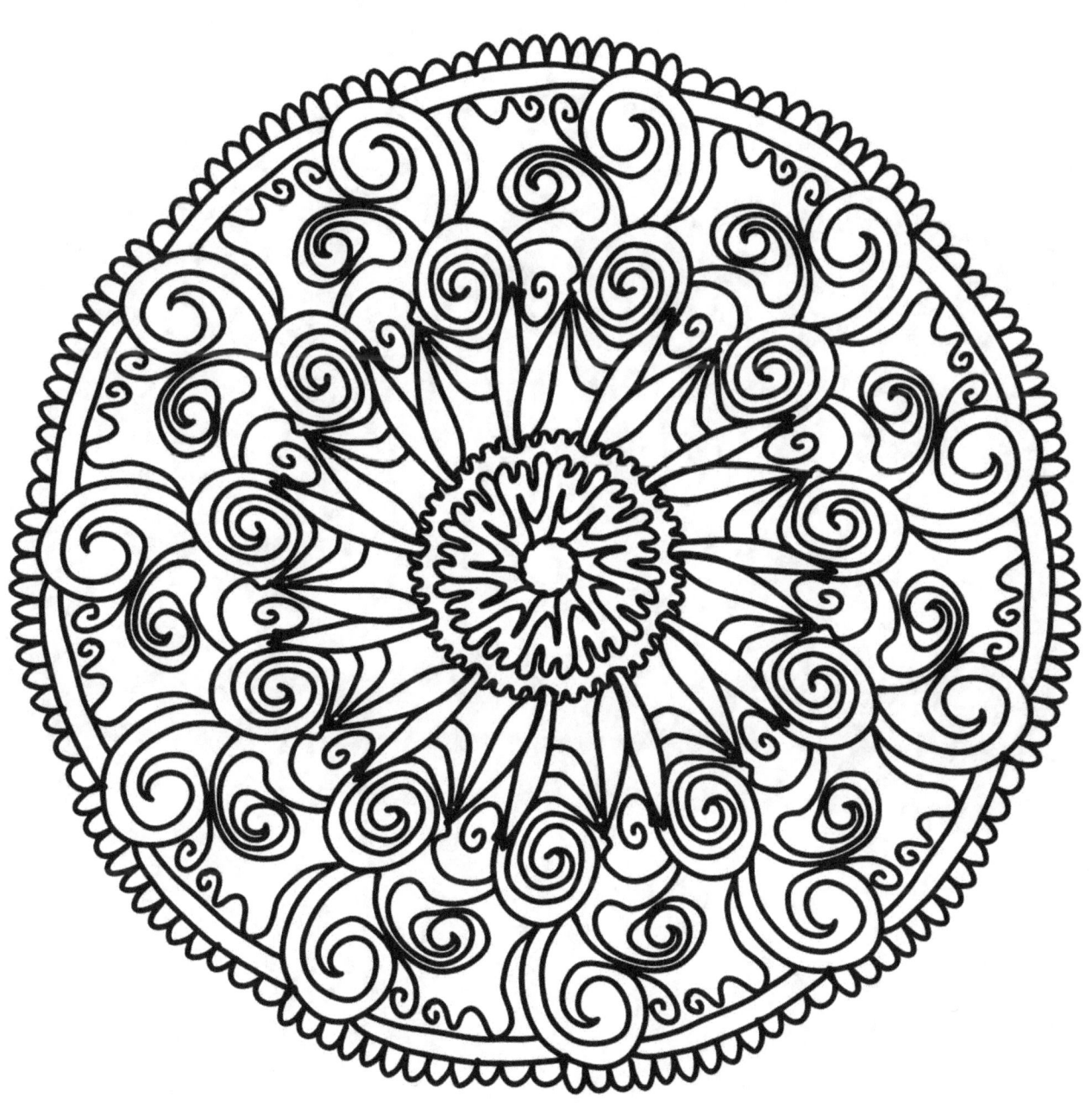

Mandalas are Relaxing

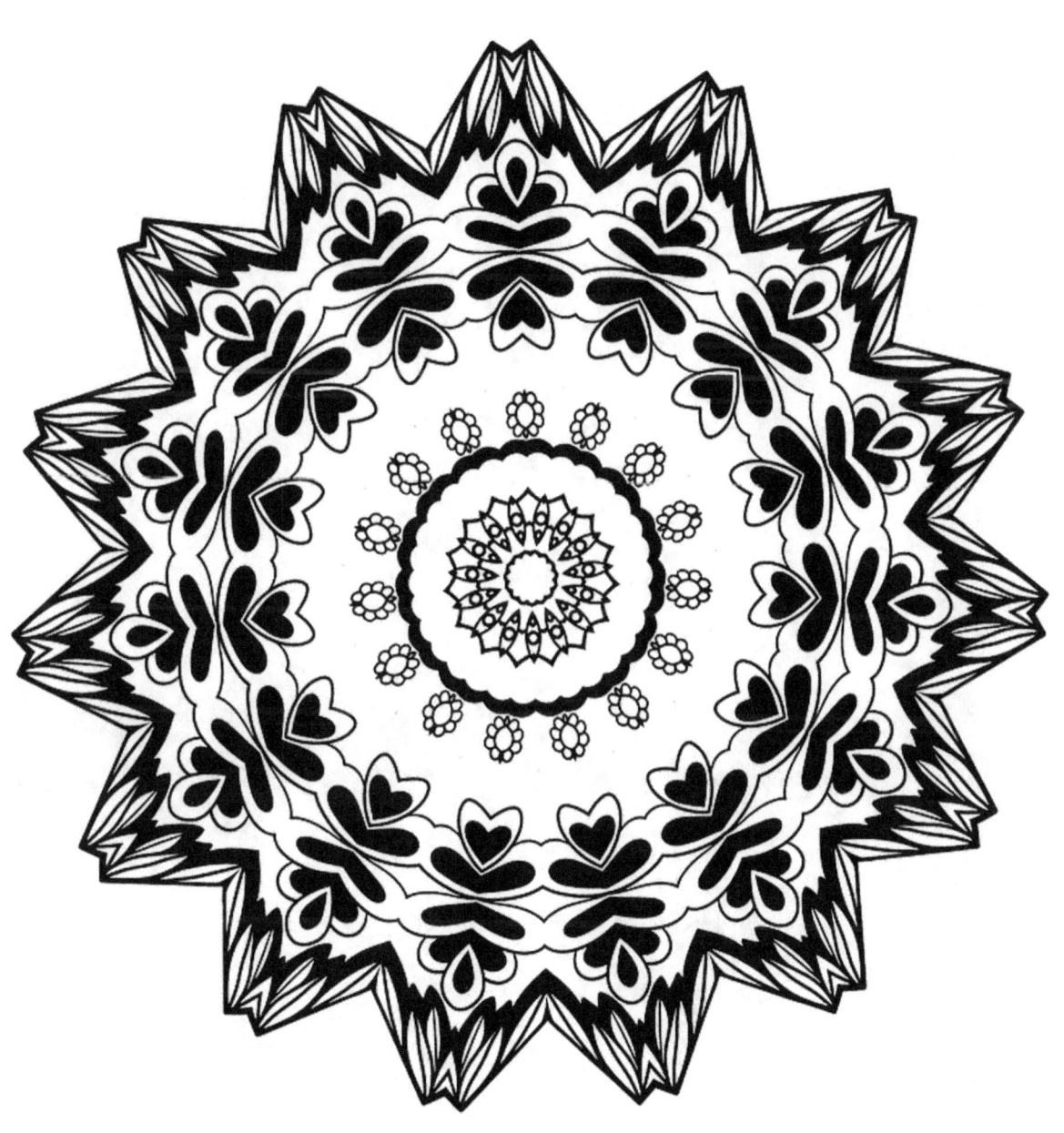

Mandalas are Relaxing

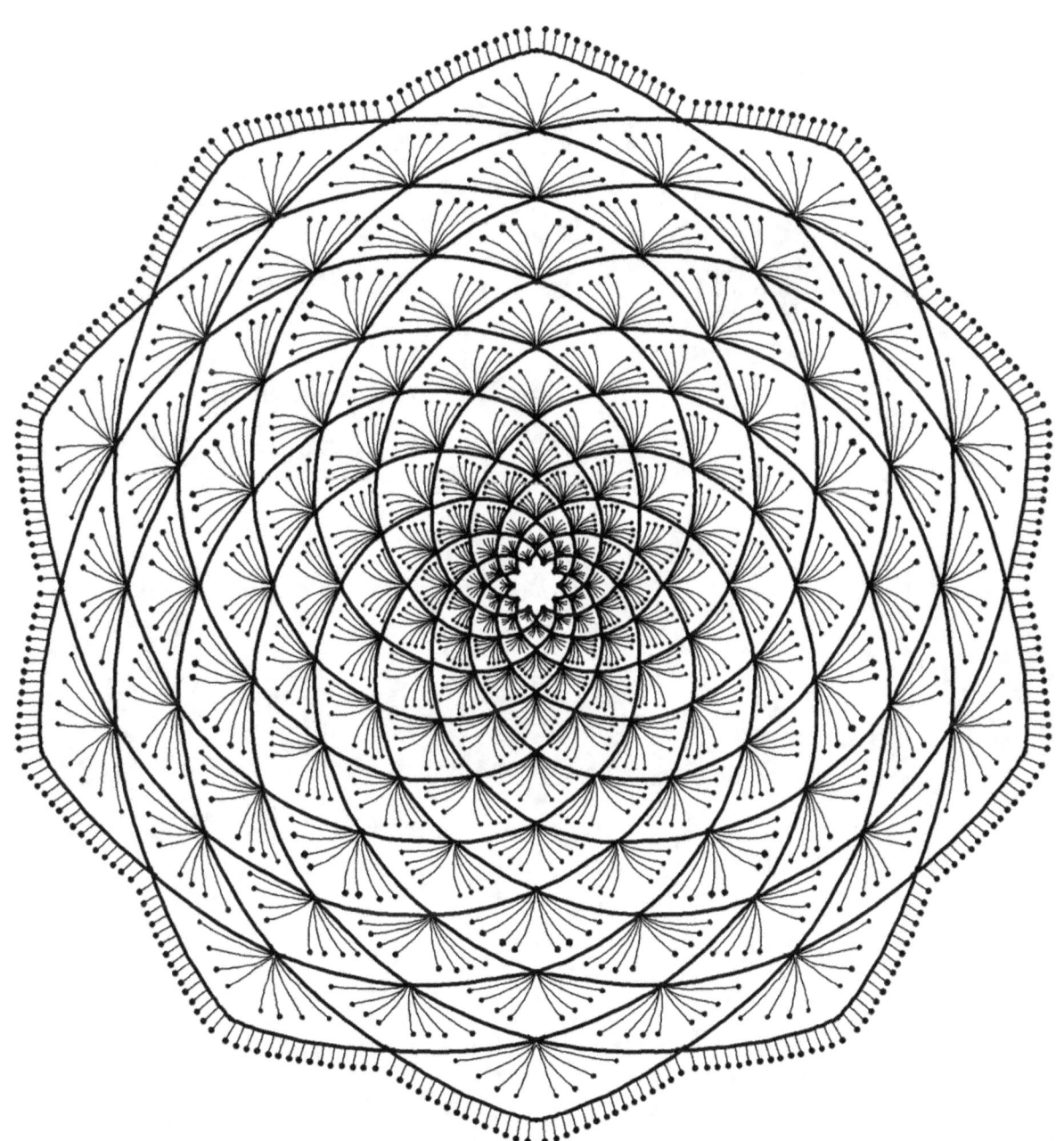

Mandalas are Relaxing

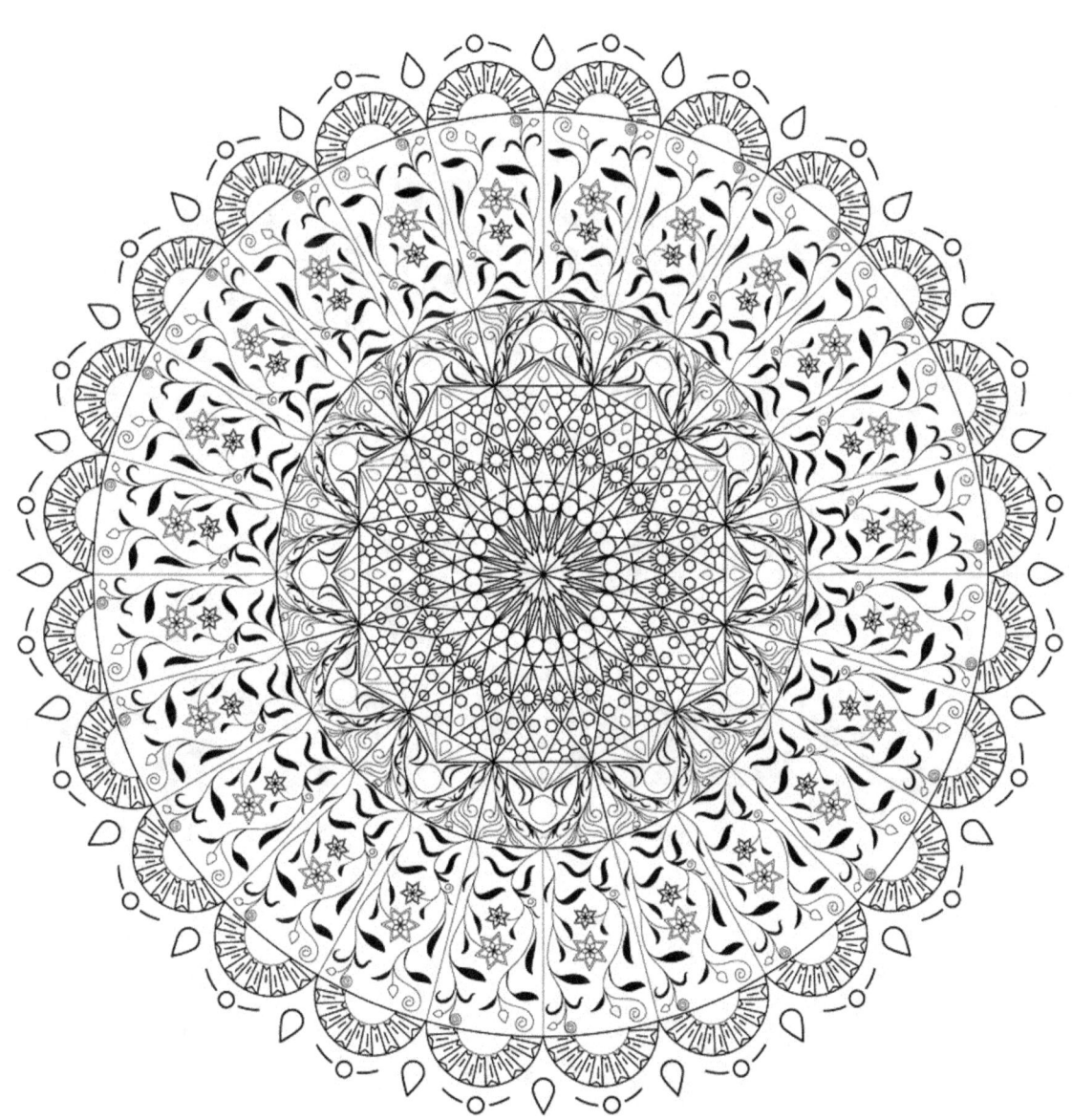

Mandalas are Relaxing

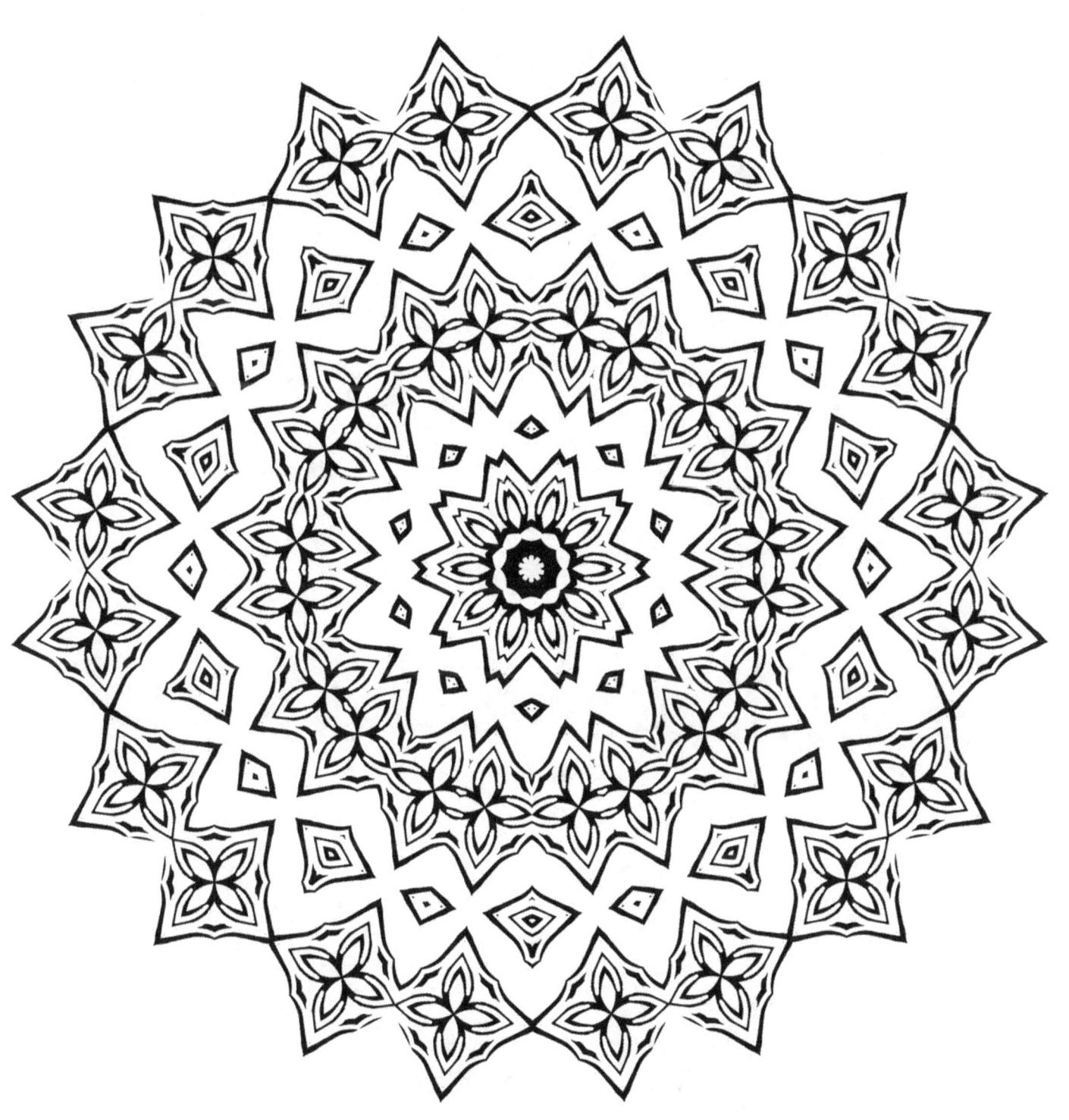

Mandalas are Relaxing

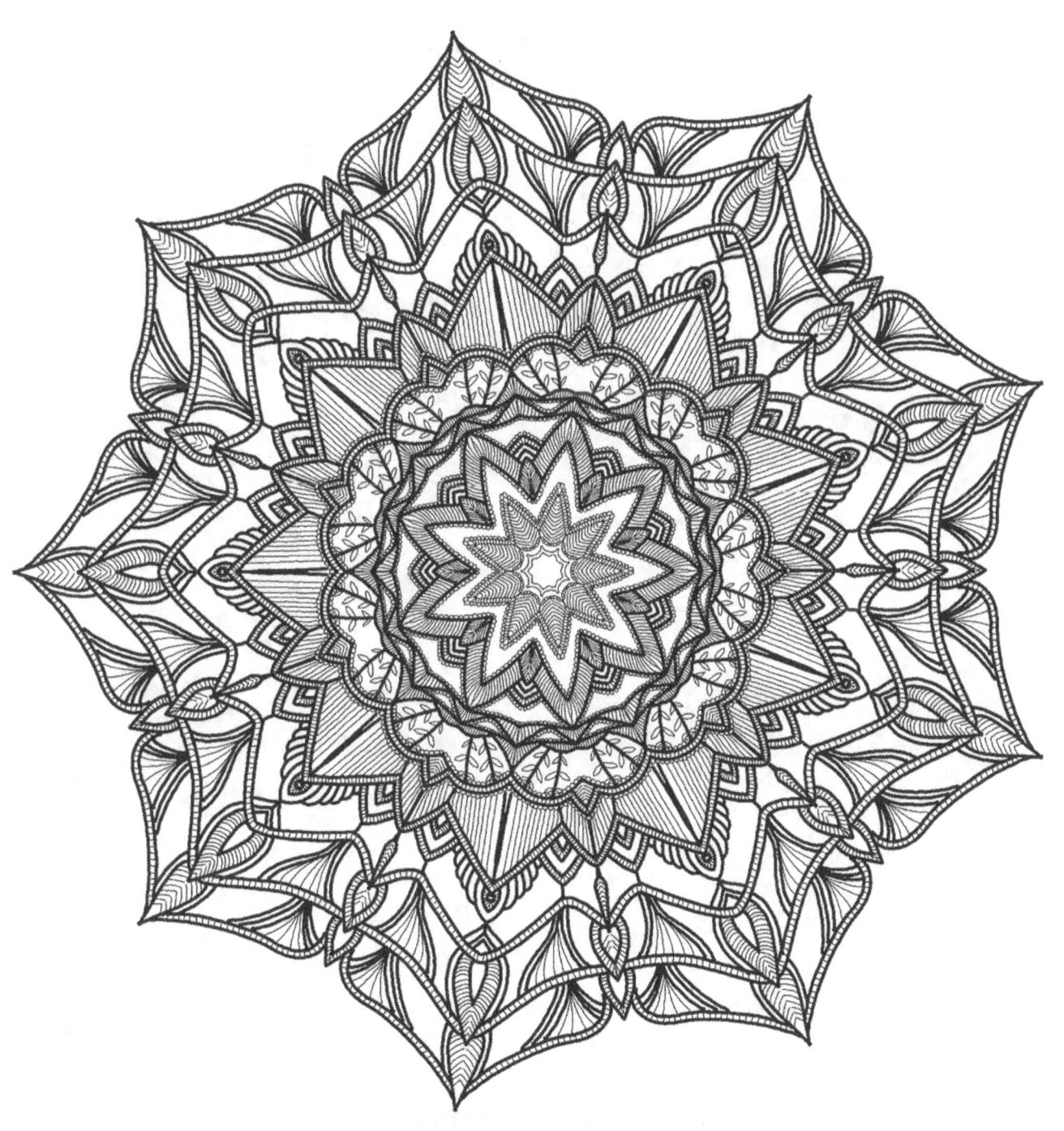

Mandalas are Relaxing

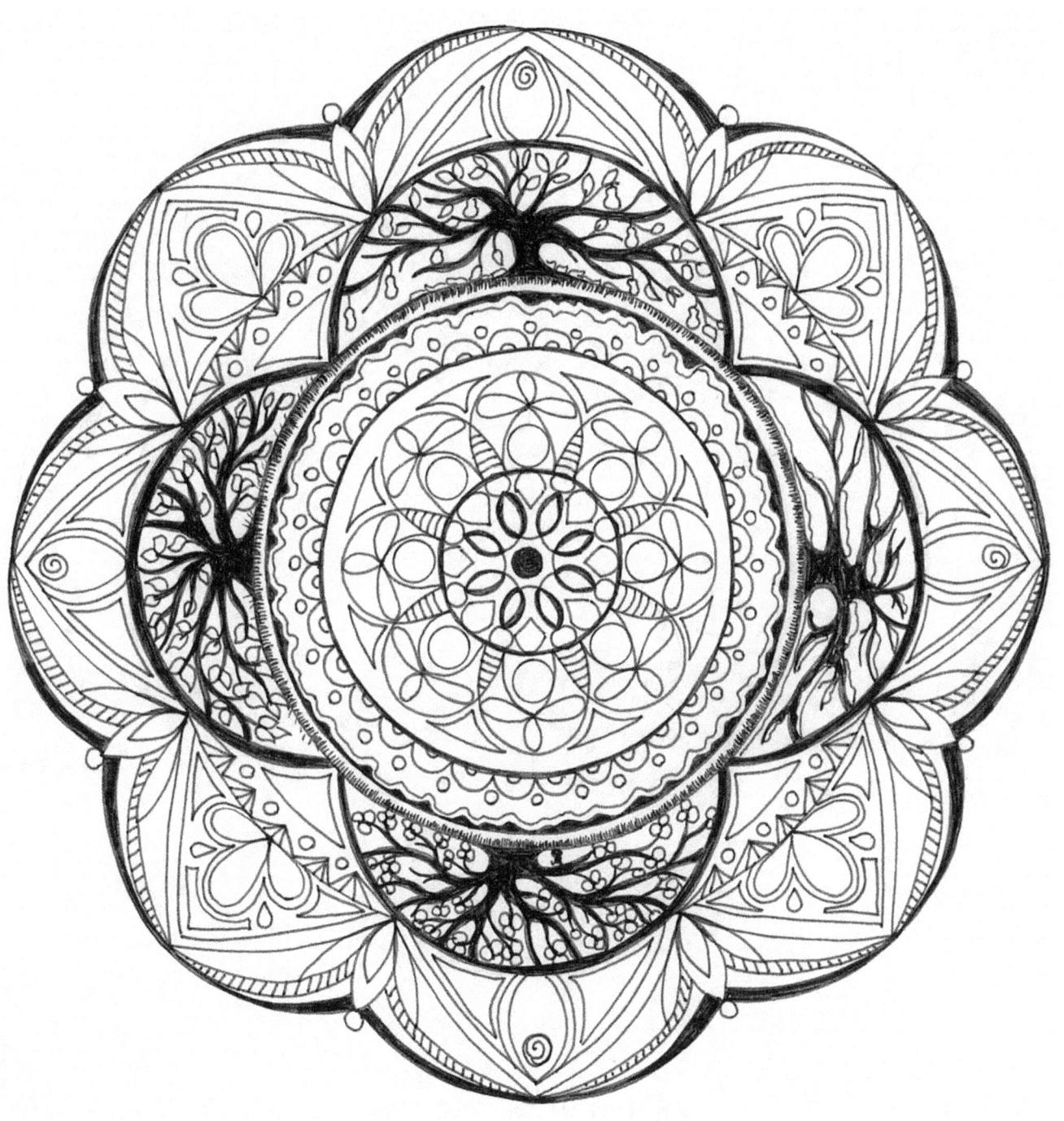

Mandalas are Relaxing

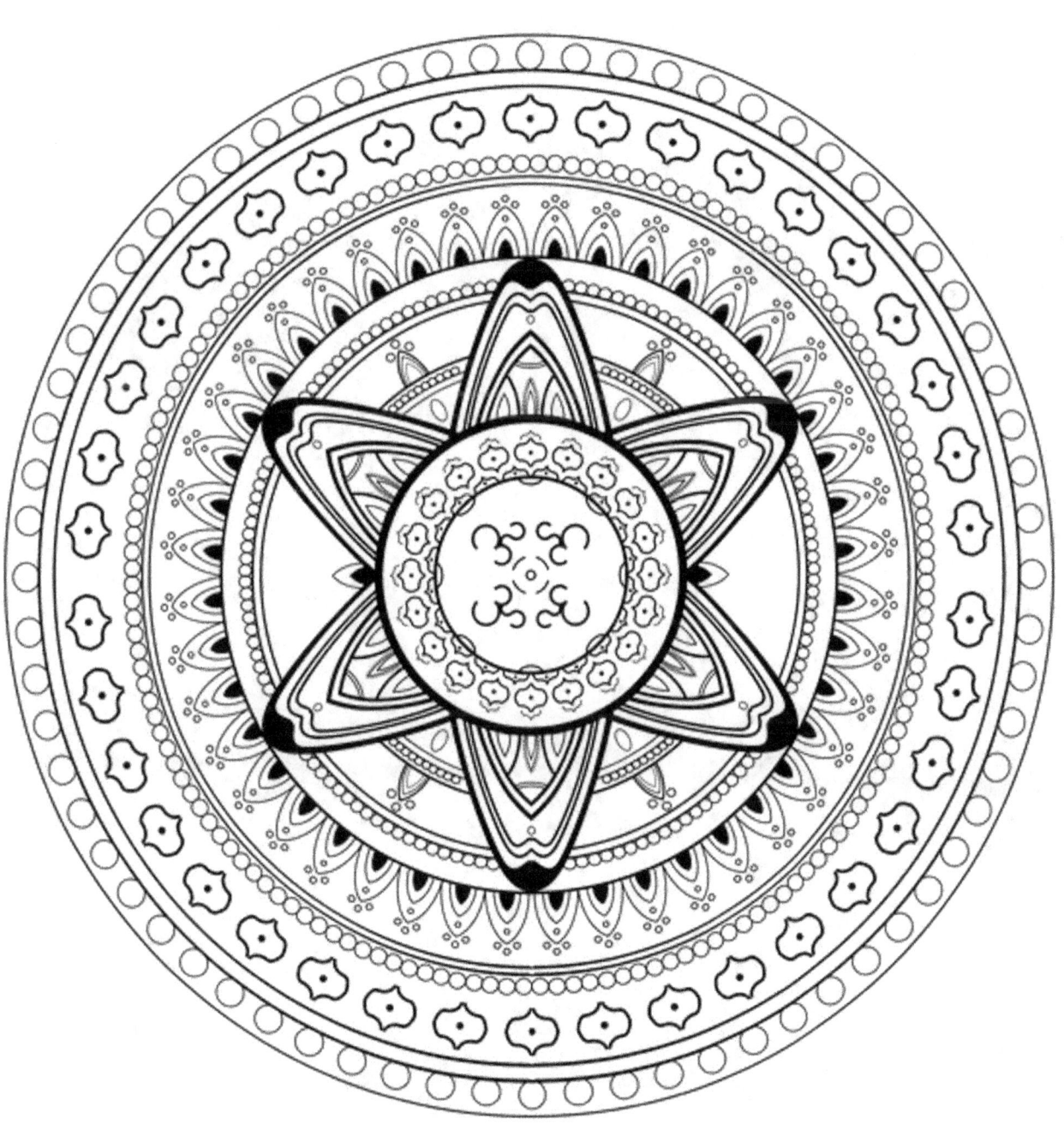

Mandalas are Relaxing

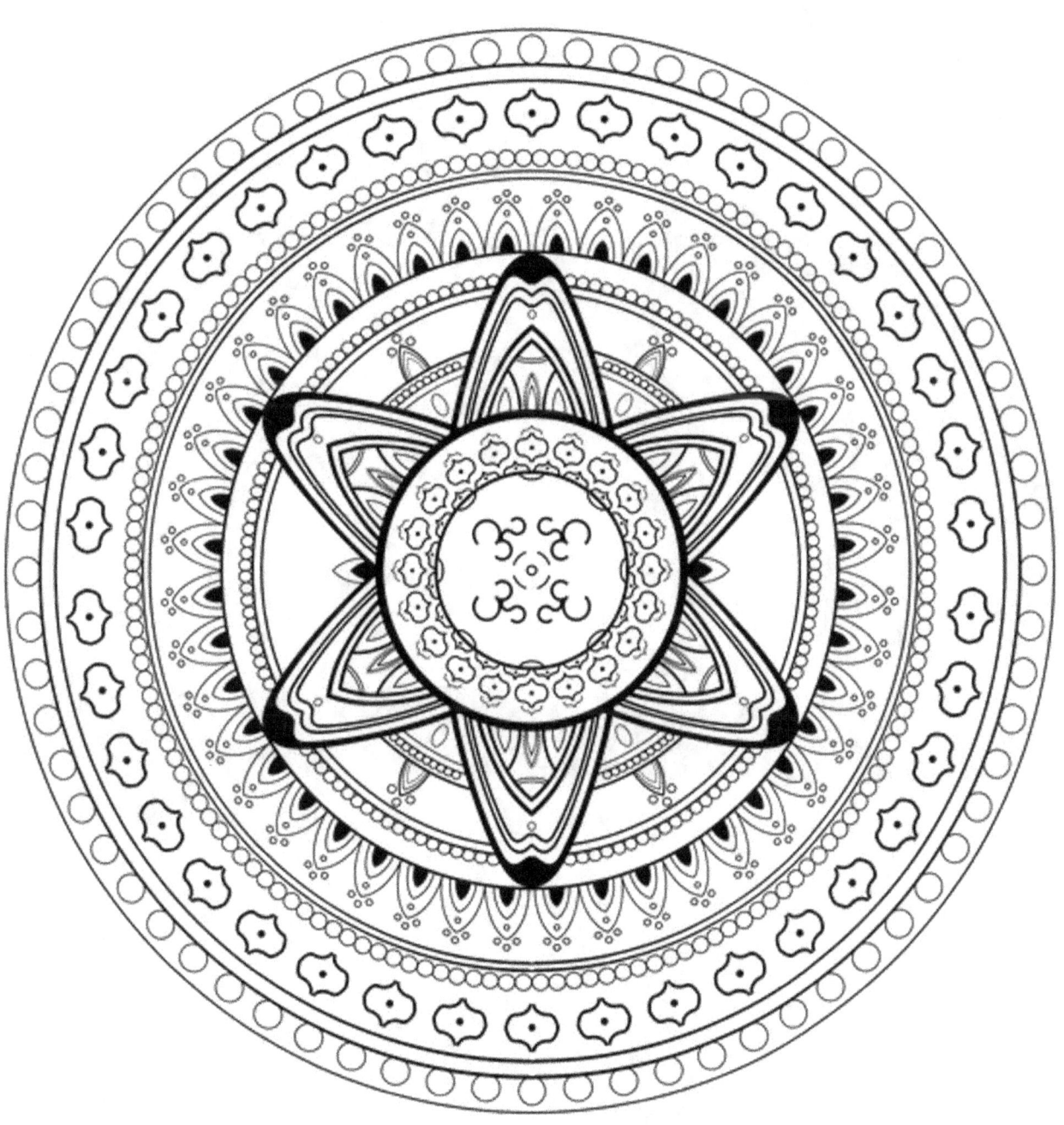

Mandalas are Relaxing

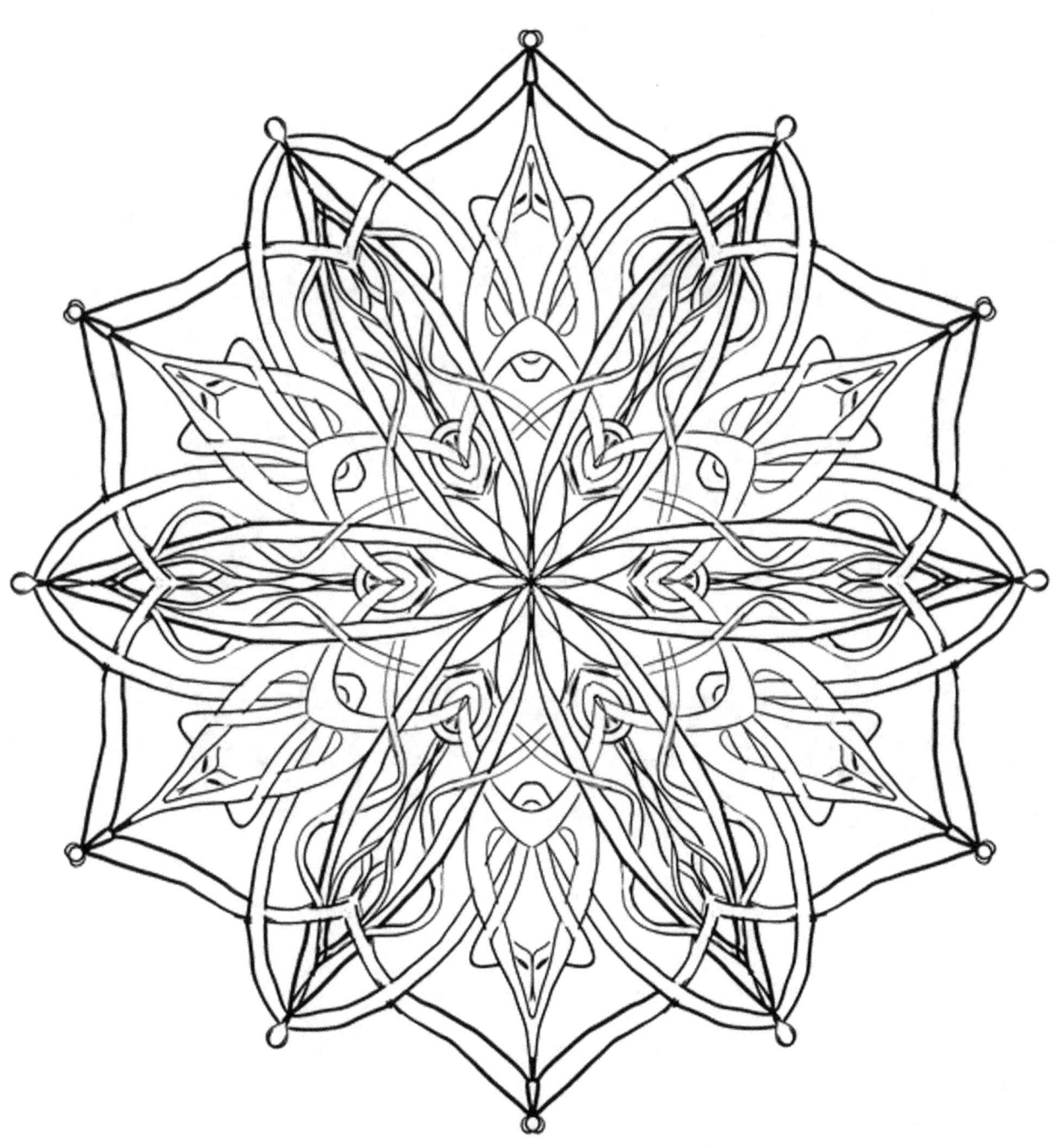

Mandalas are Relaxing

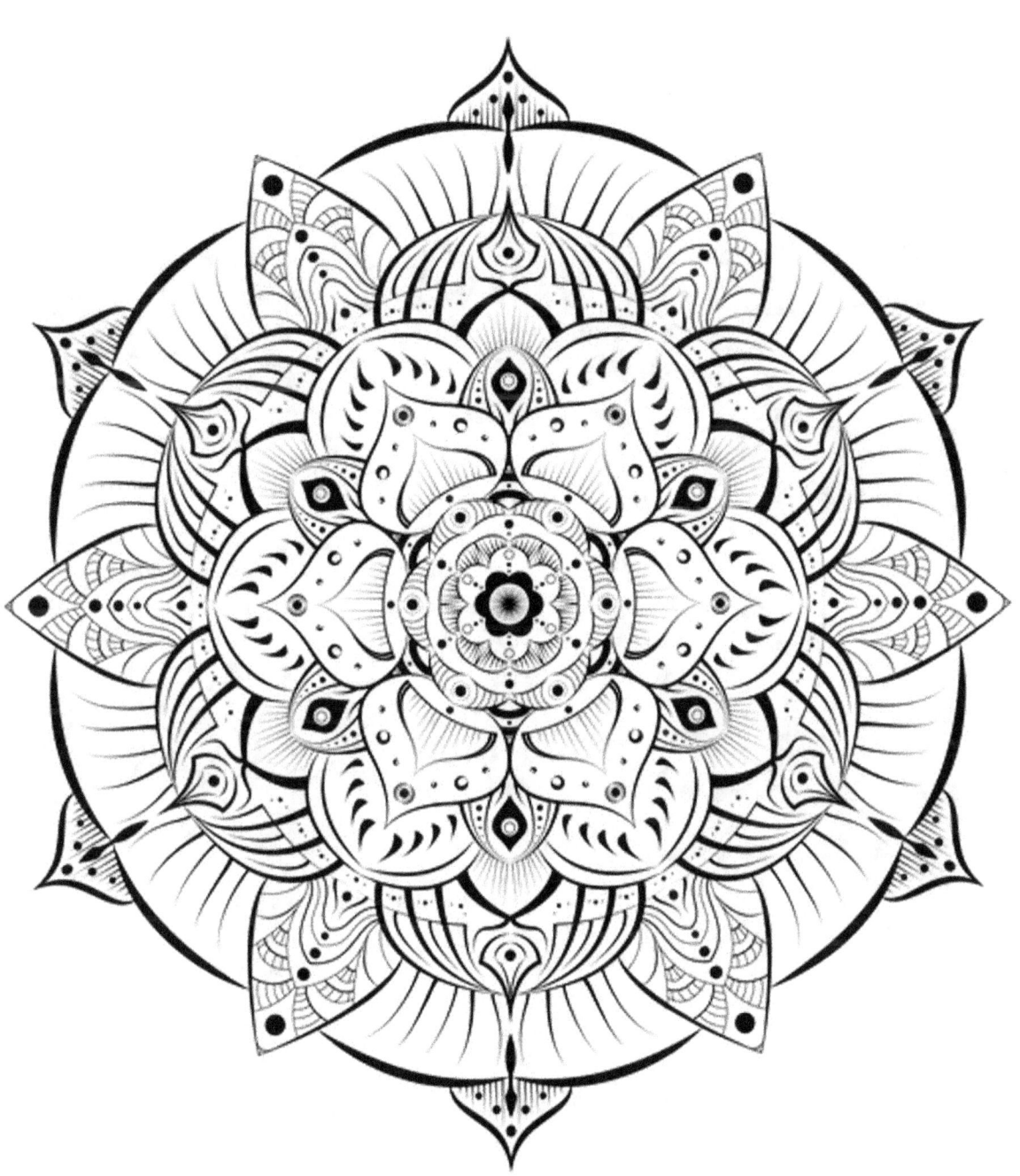

Mandalas are Relaxing

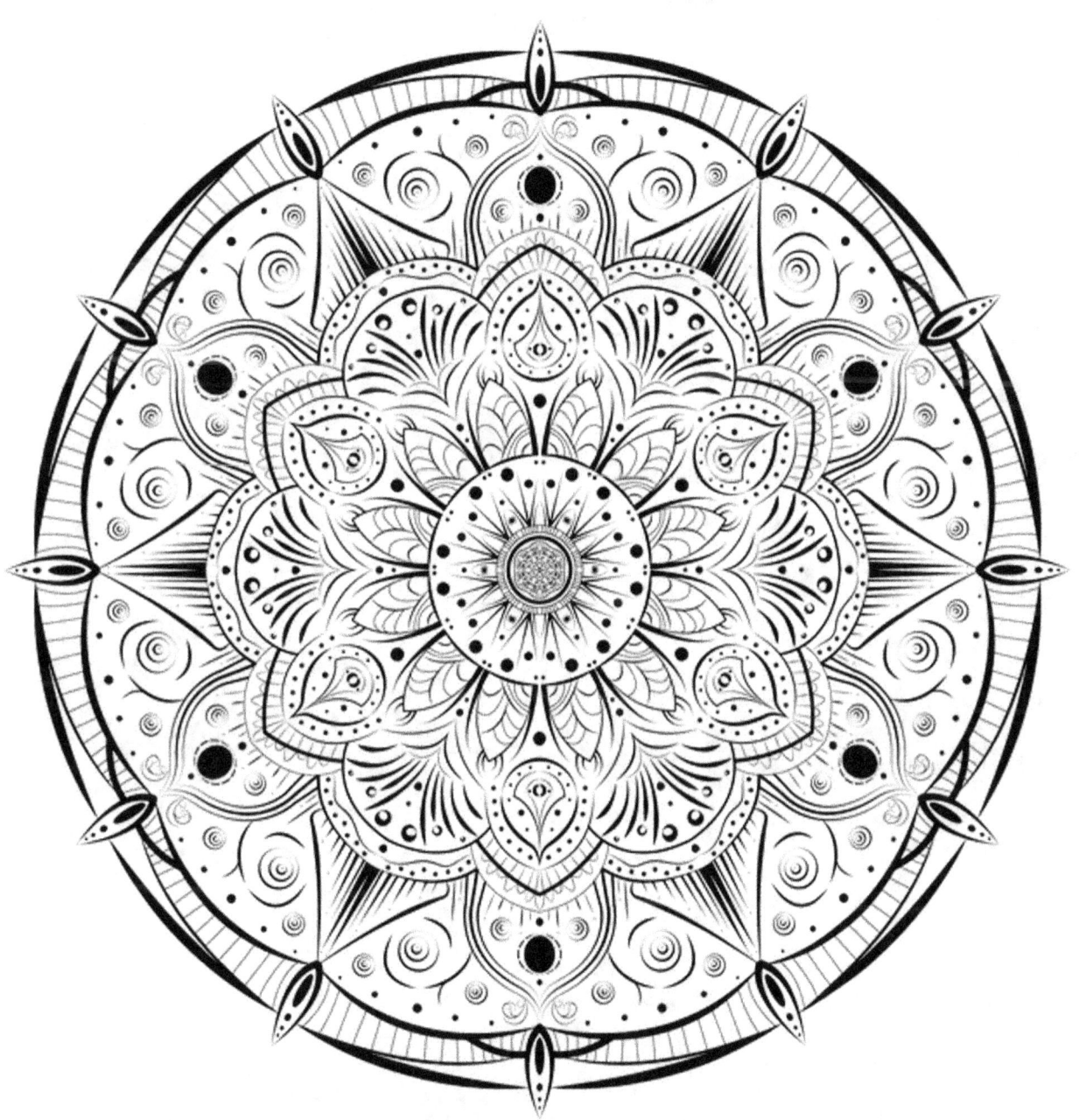

Mandalas are Relaxing

Mandalas are Relaxing

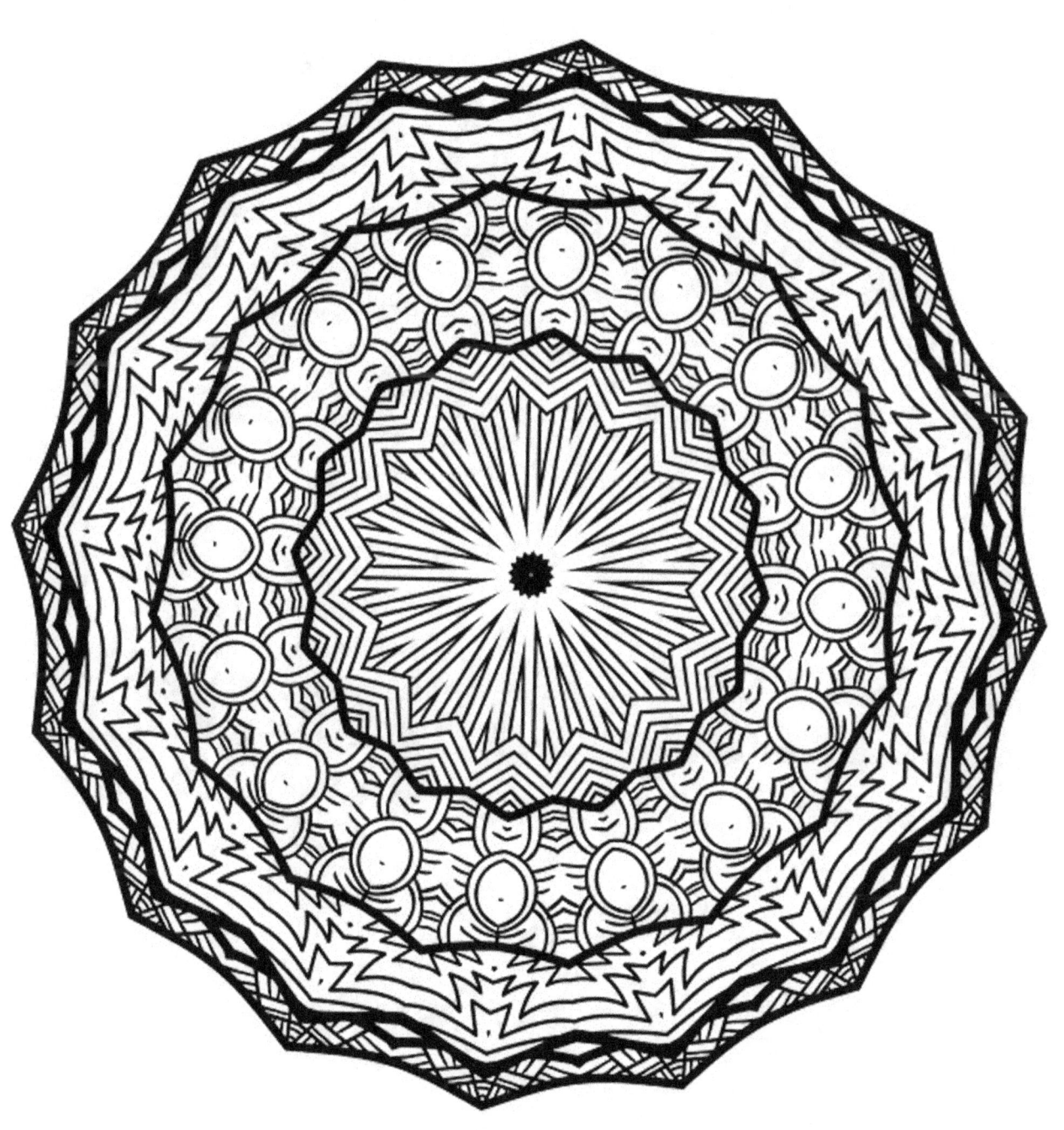

Mandalas are Relaxing

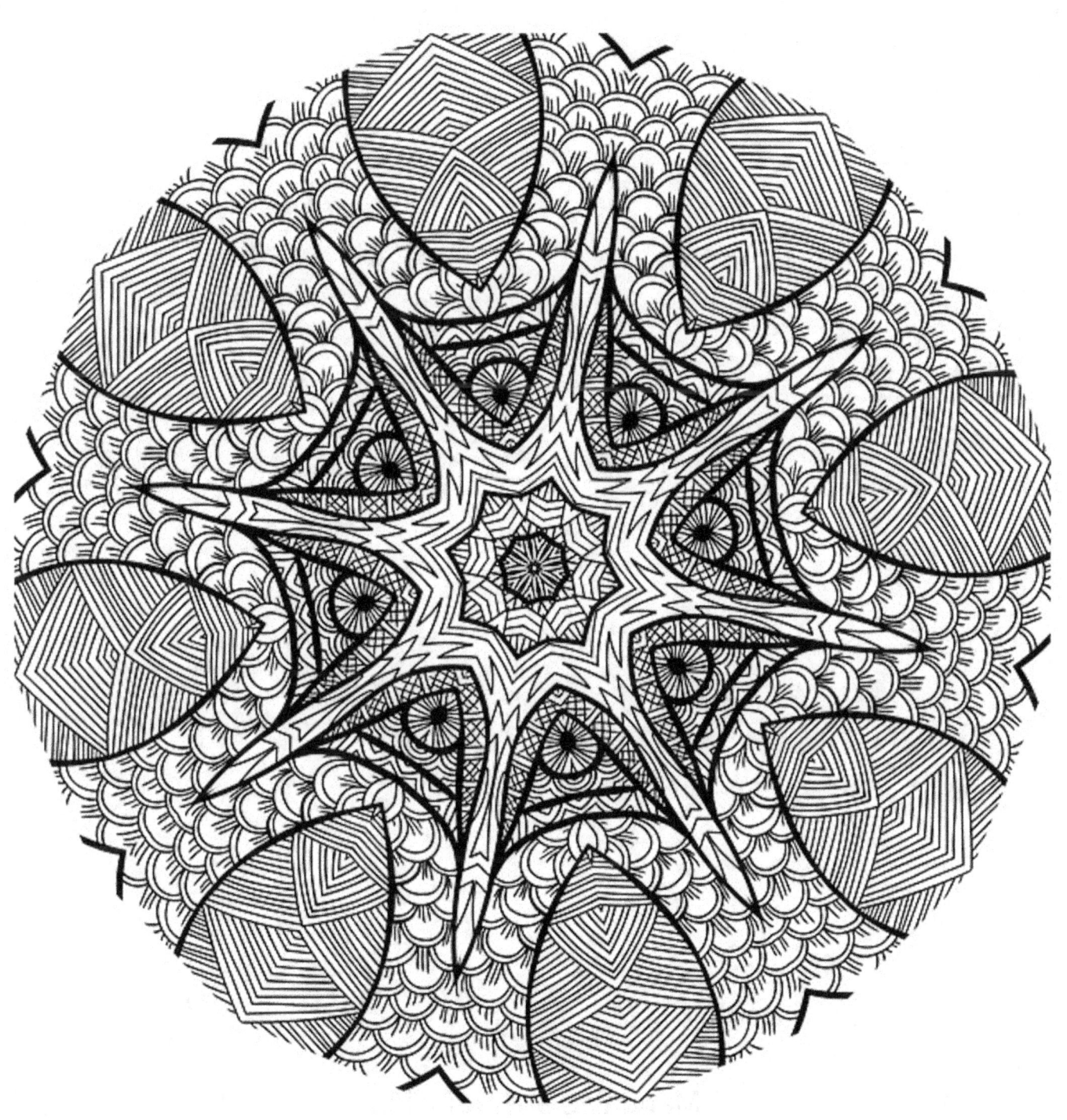

Mandalas are Relaxing

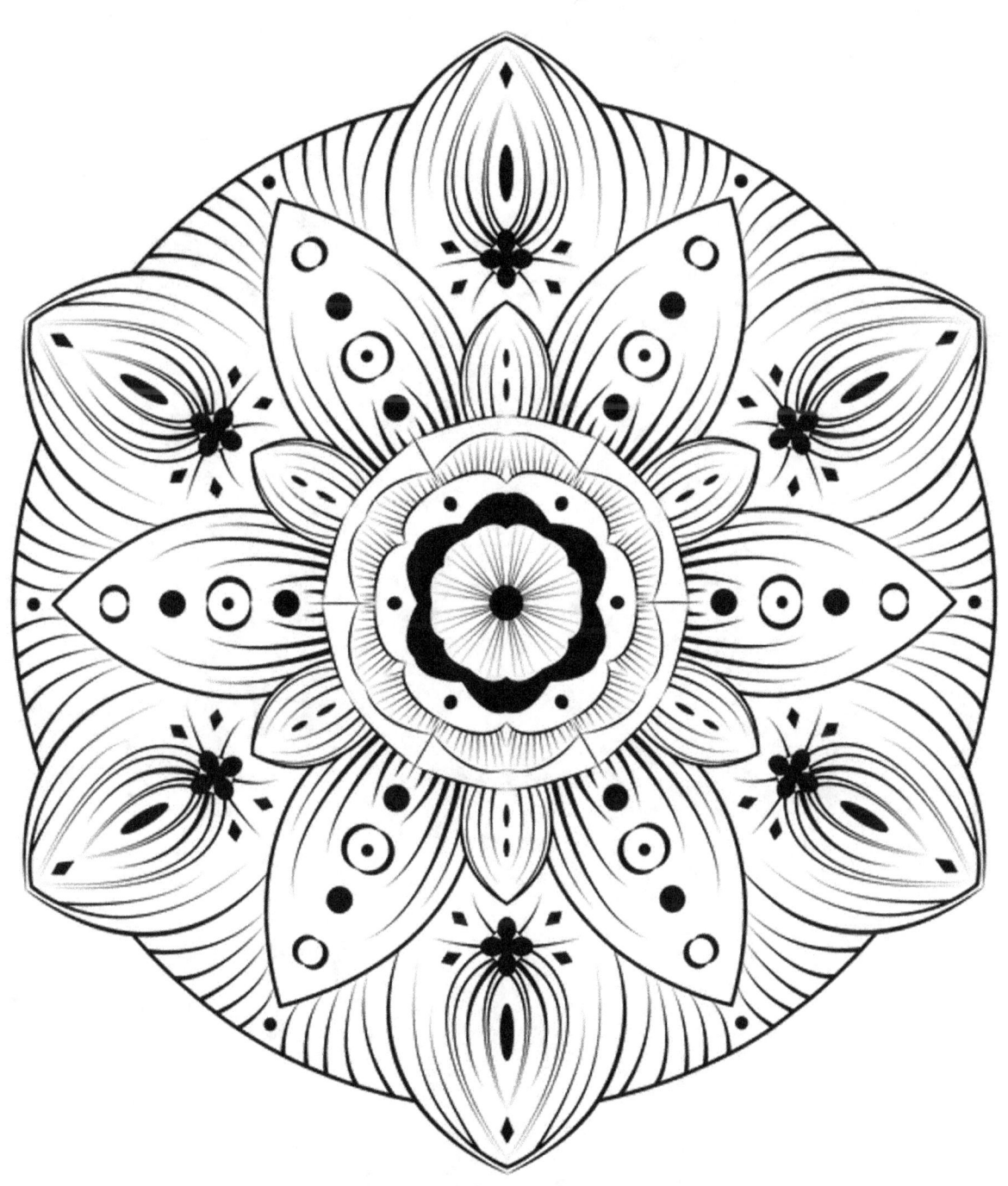

Mandalas are Relaxing

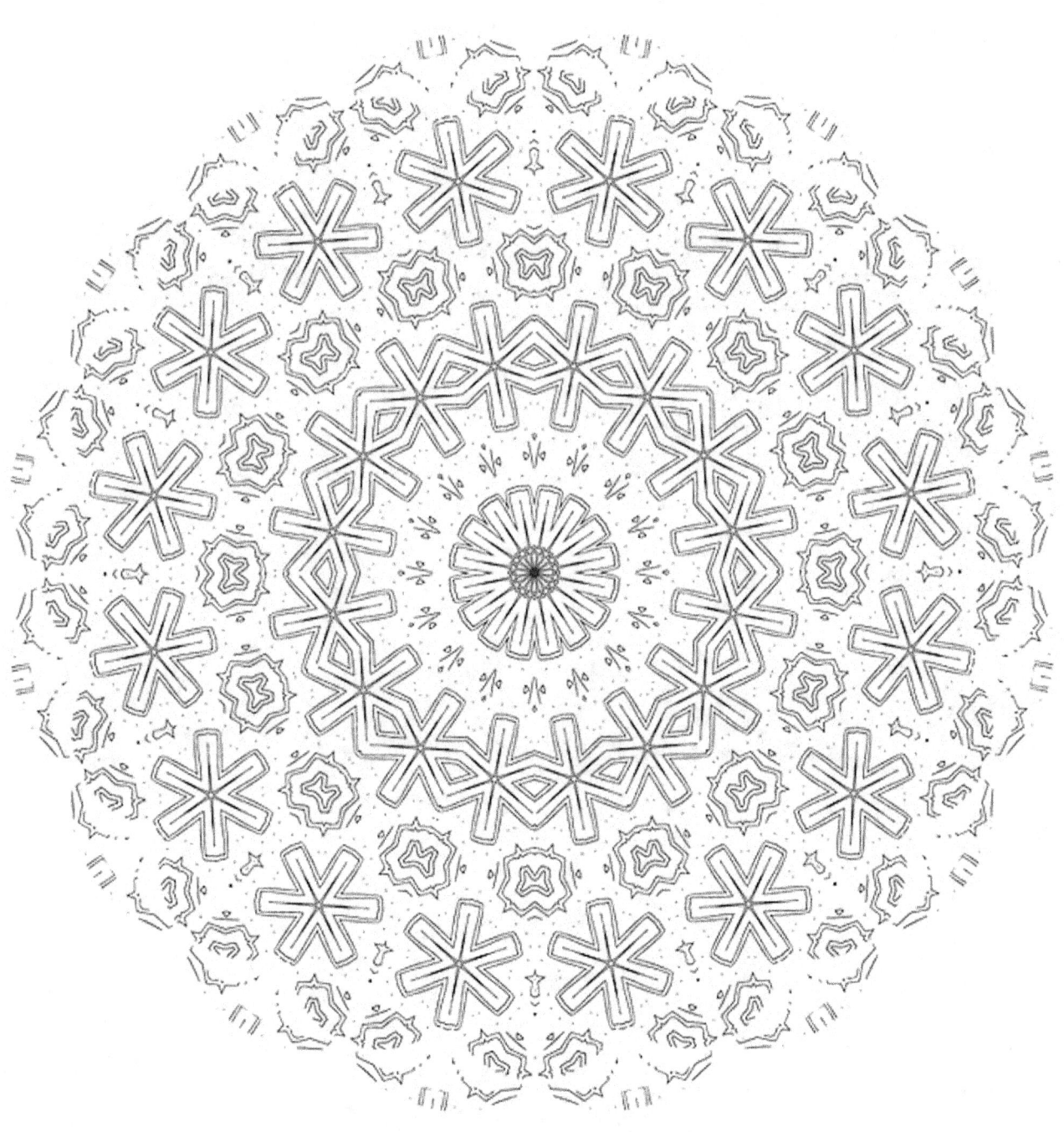

Mandalas are Relaxing

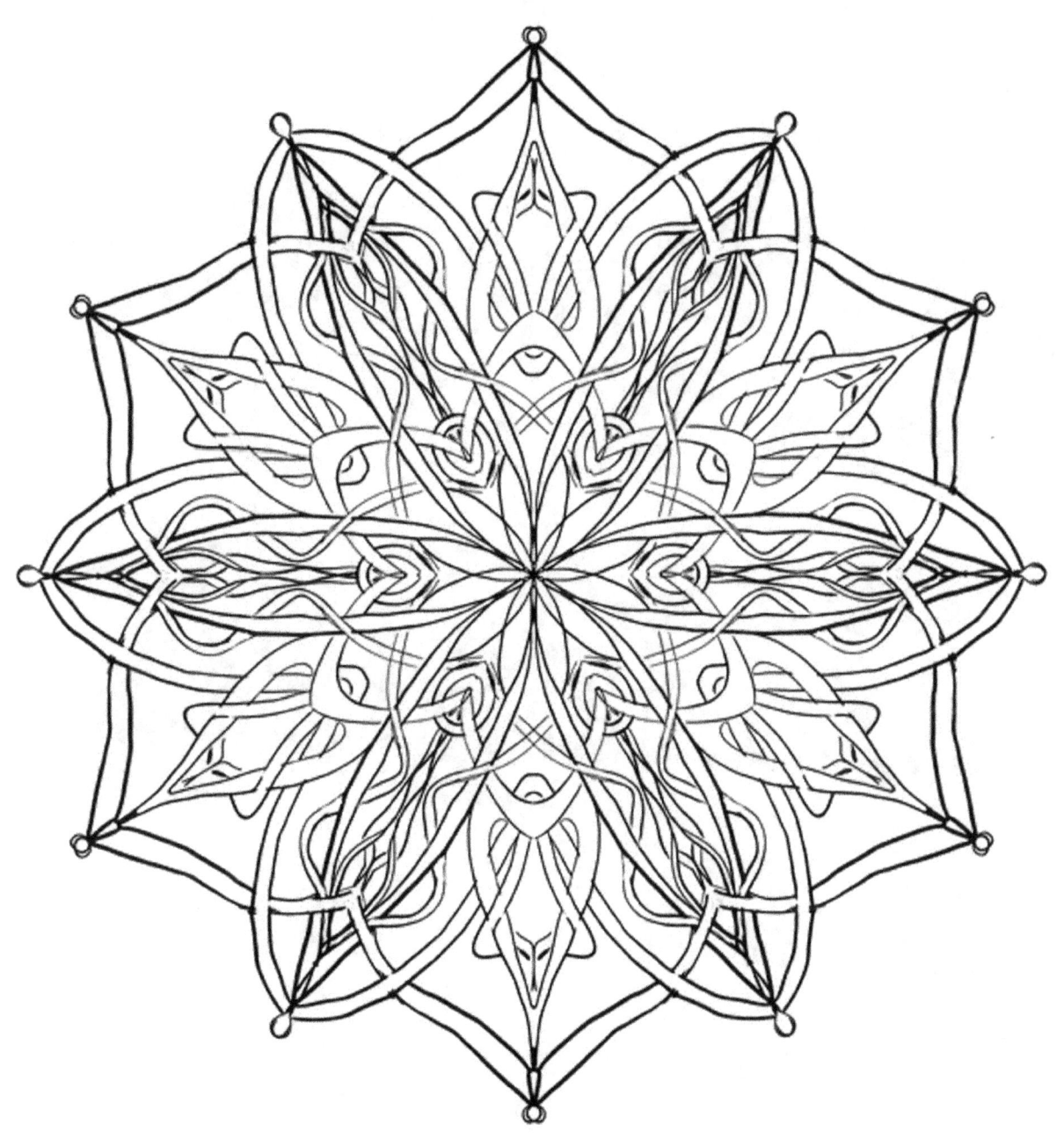

Mandalas are Relaxing

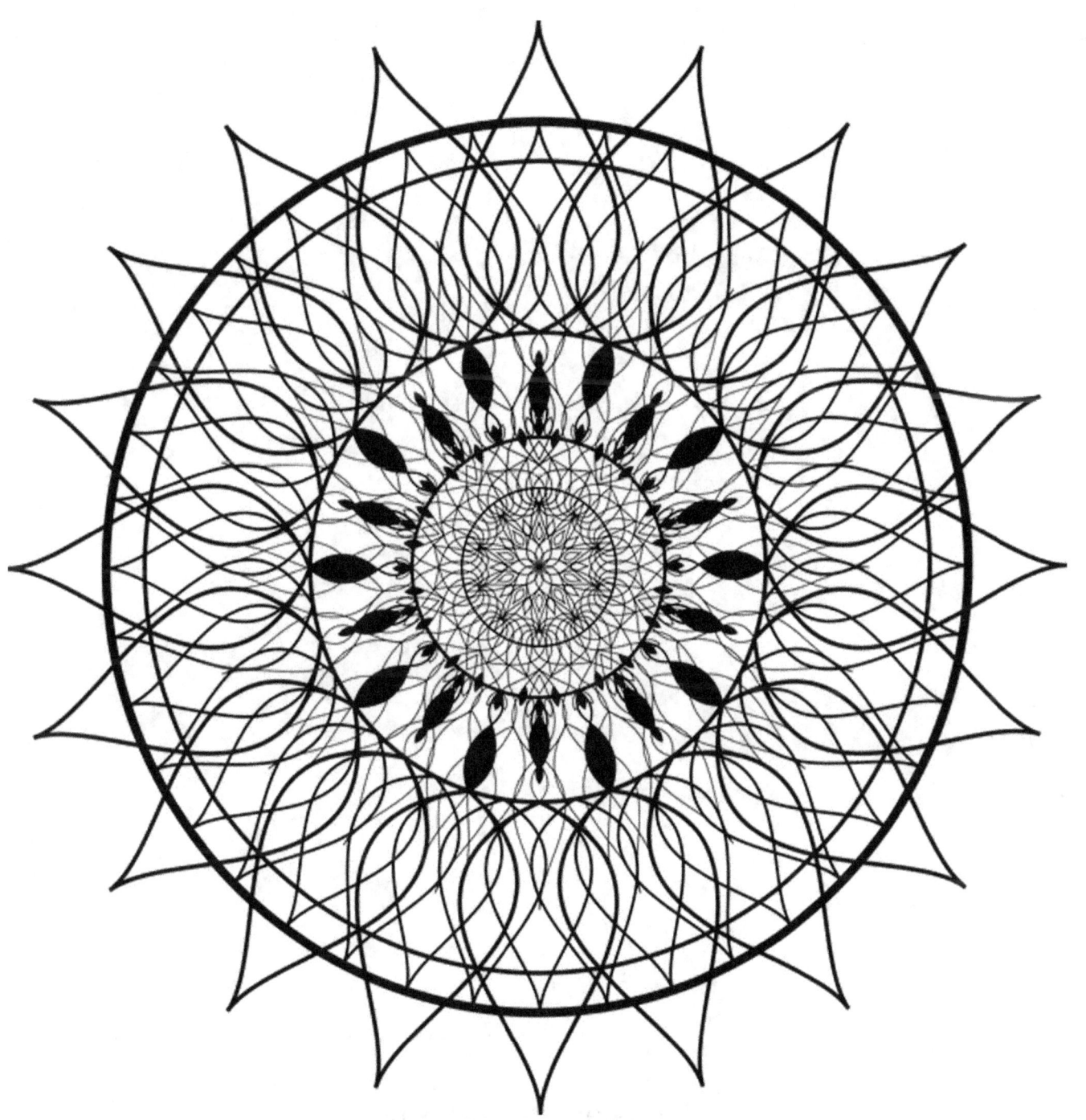

Mandalas are Relaxing

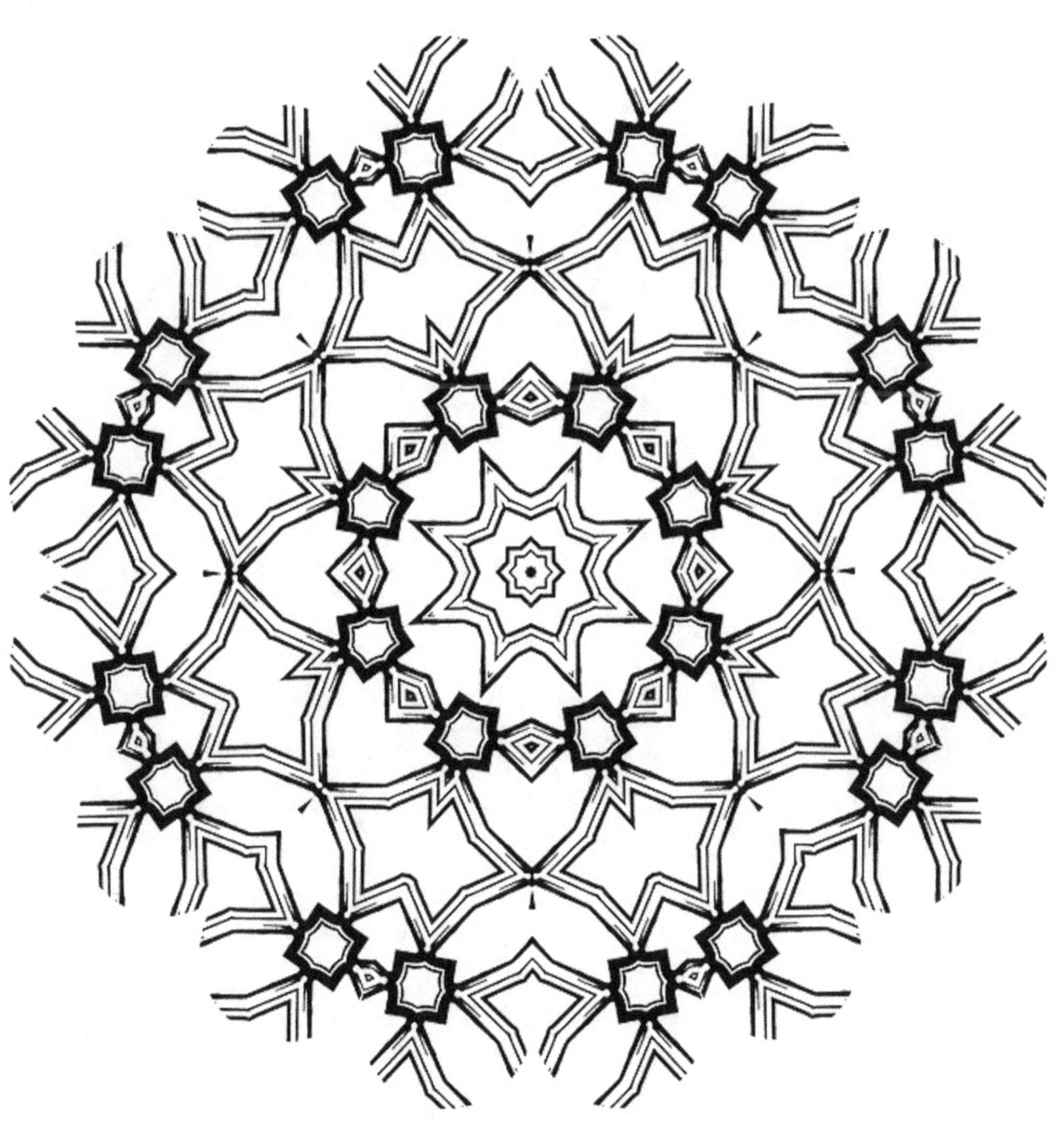

Mandalas are Relaxing

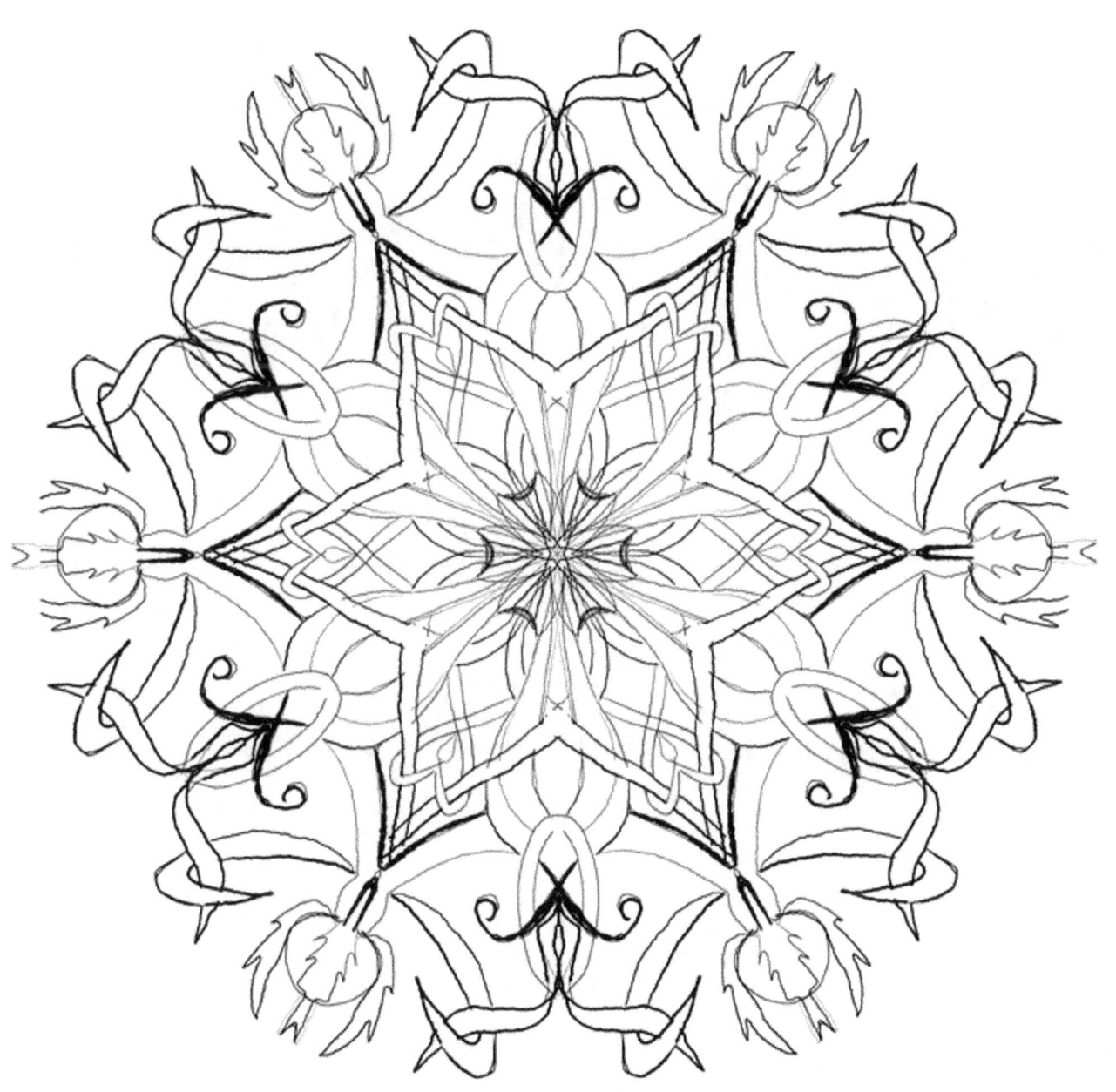

Mandalas are Relaxing

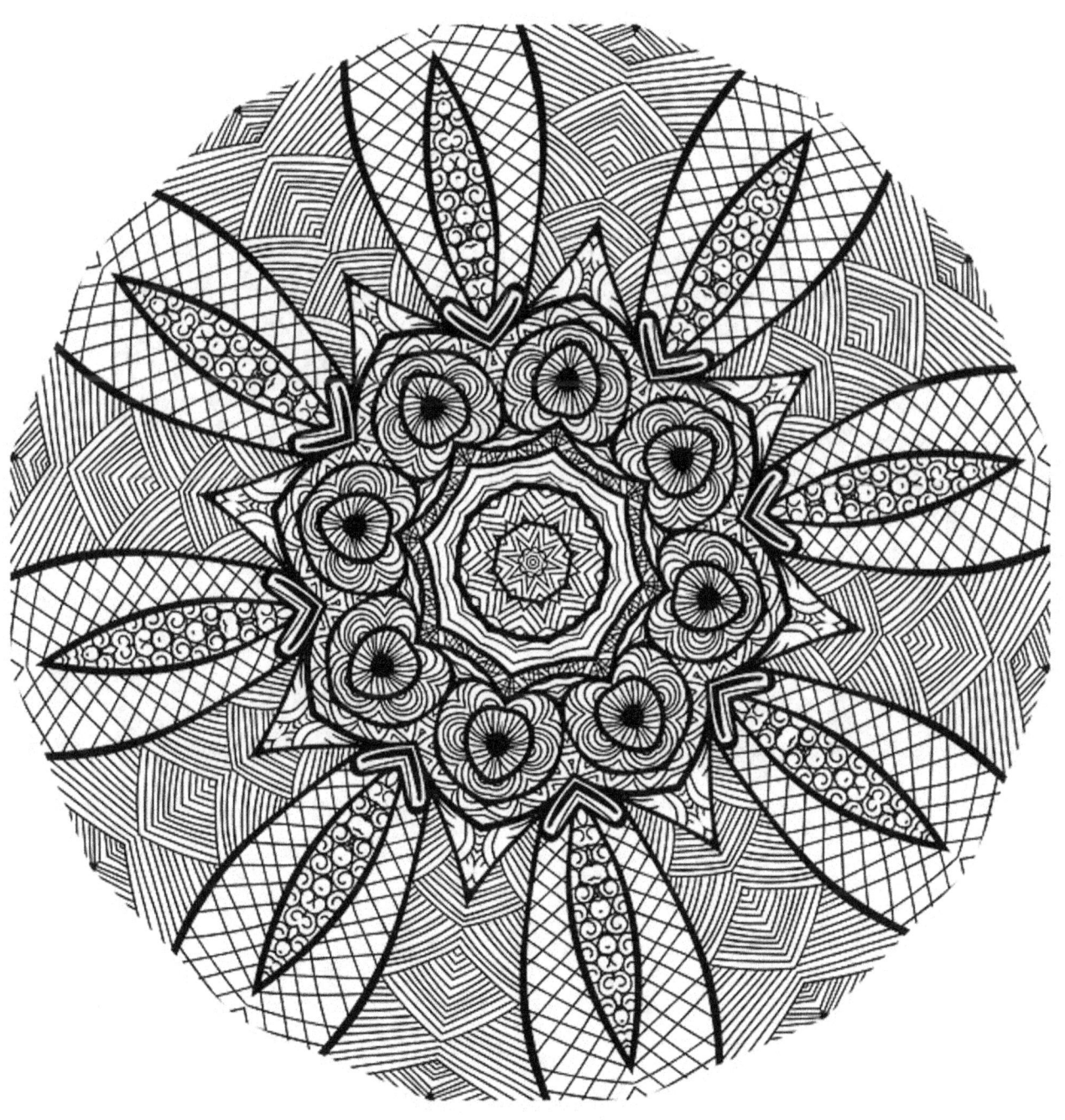

Mandalas are Relaxing

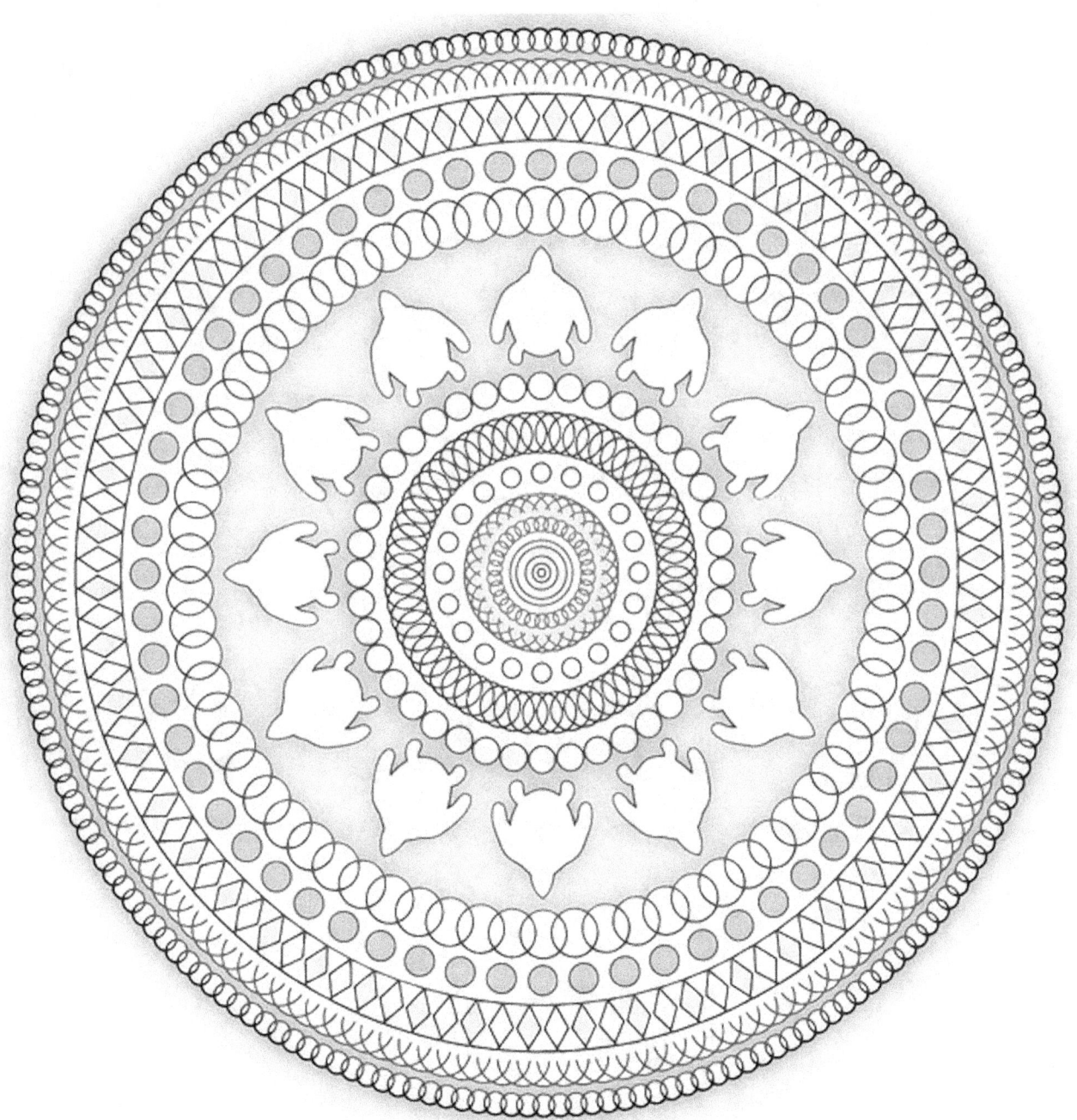

Mandalas are Relaxing

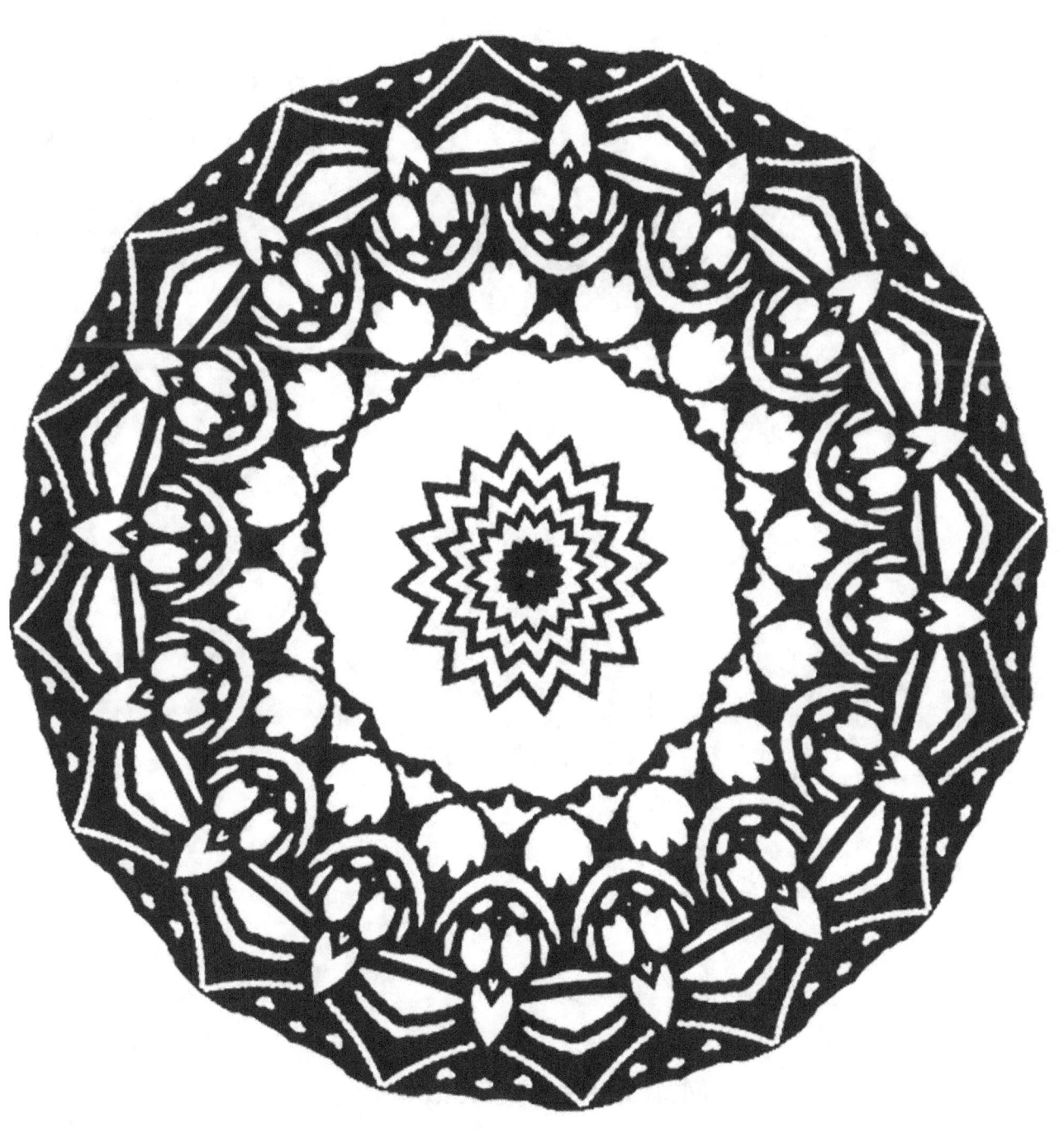

Mandalas are Relaxing

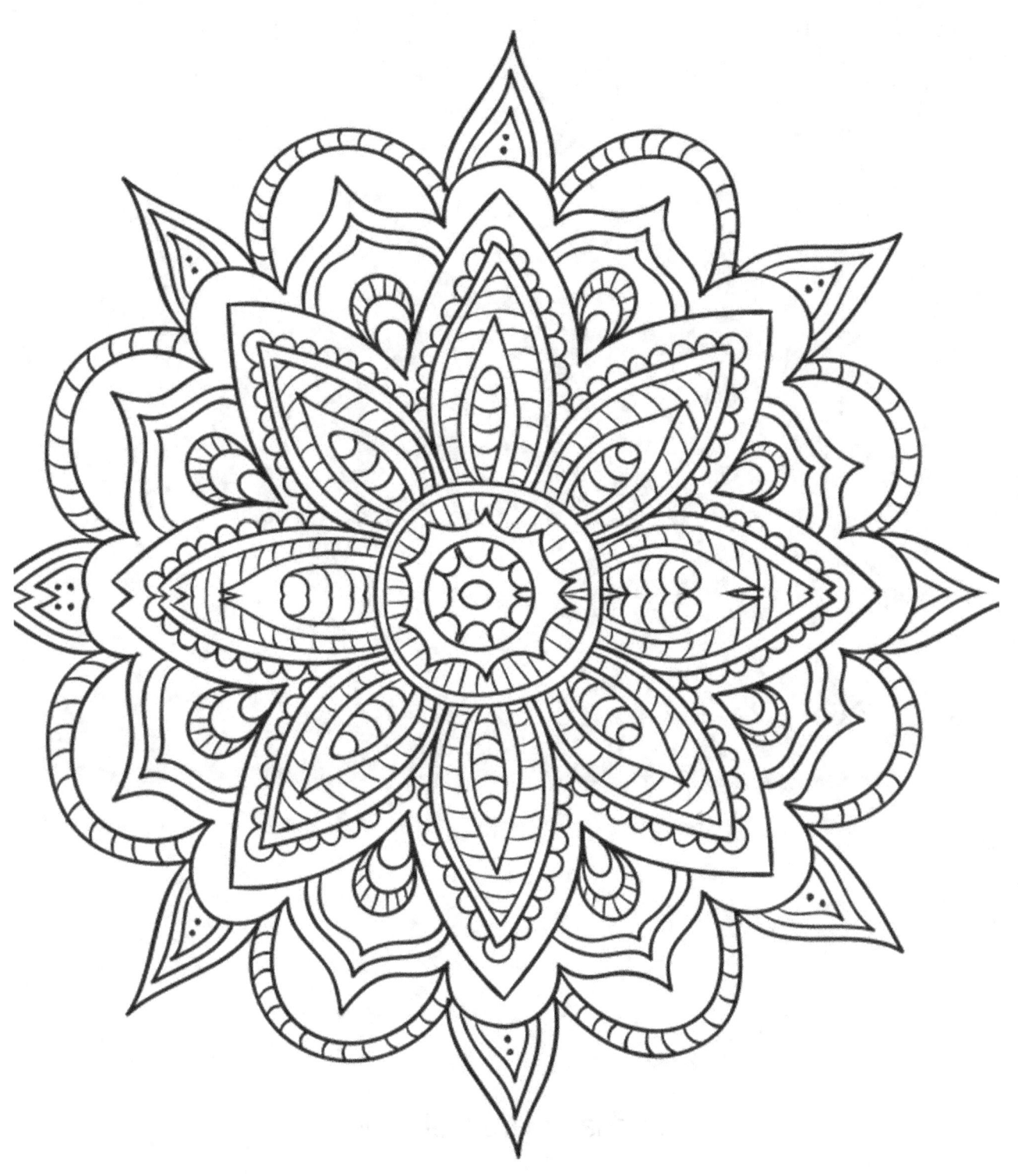

Mandalas are Relaxing

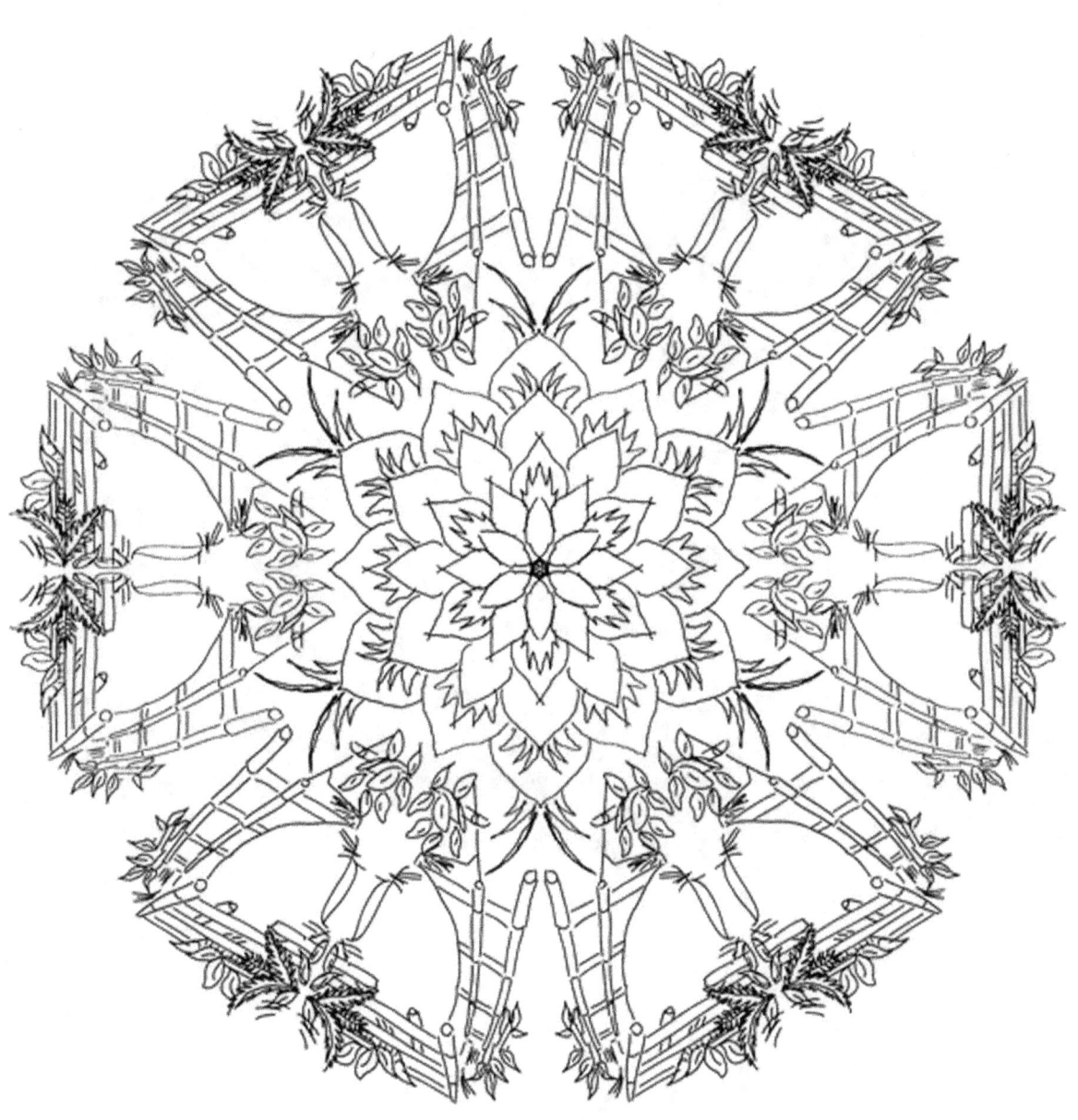

Mandalas are Relaxing

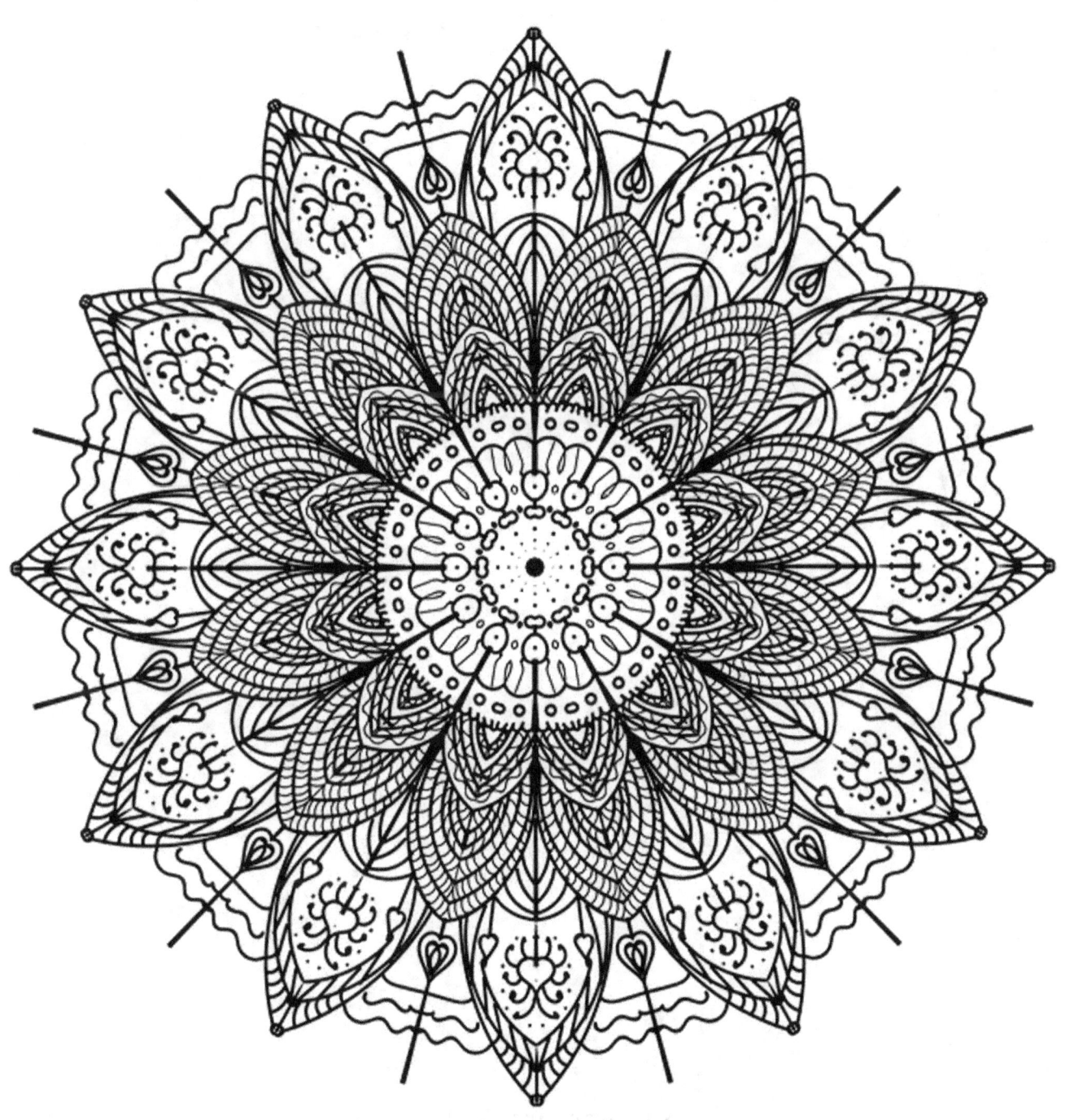

Mandalas are Relaxing

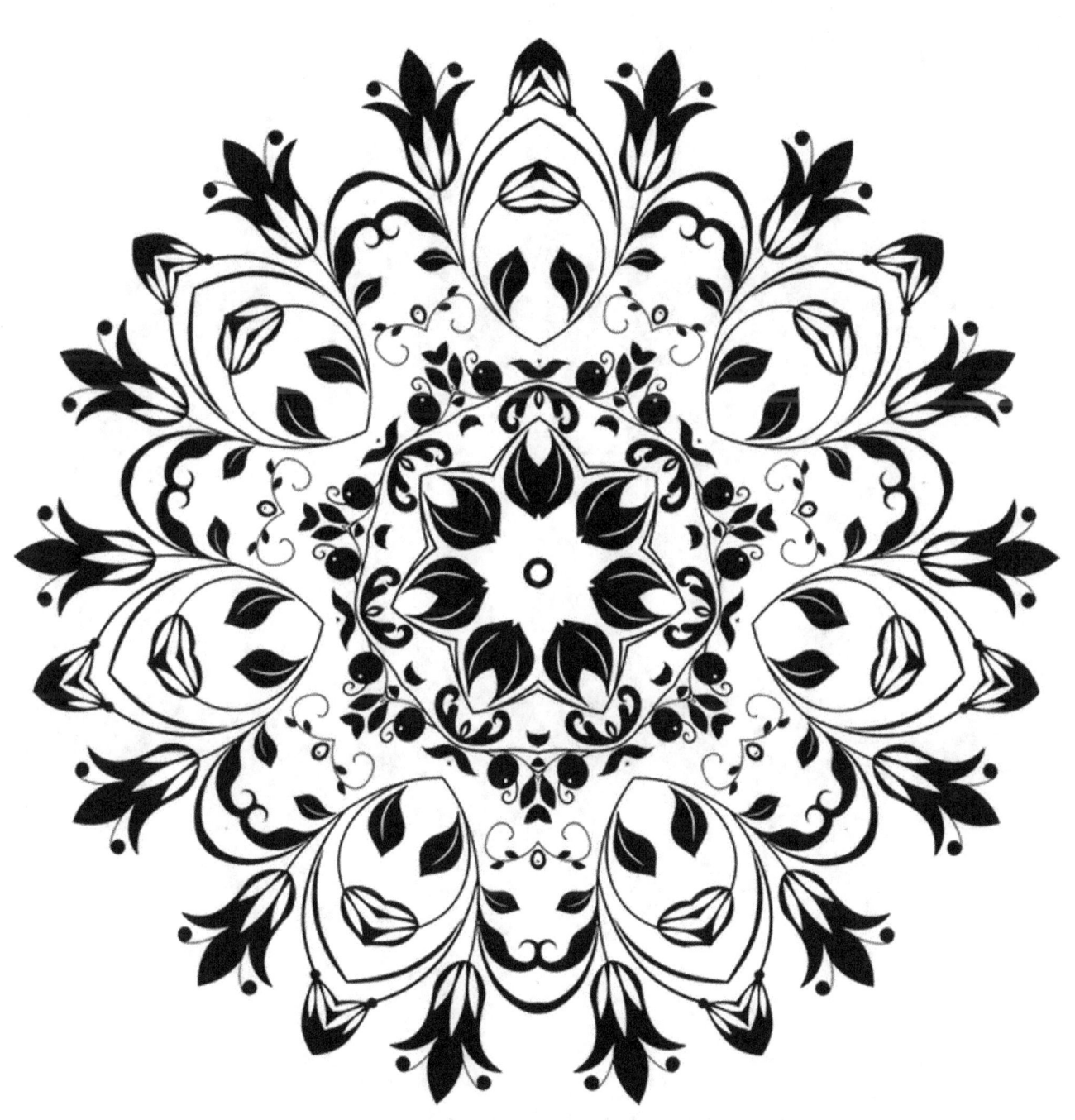

Mandalas are Relaxing

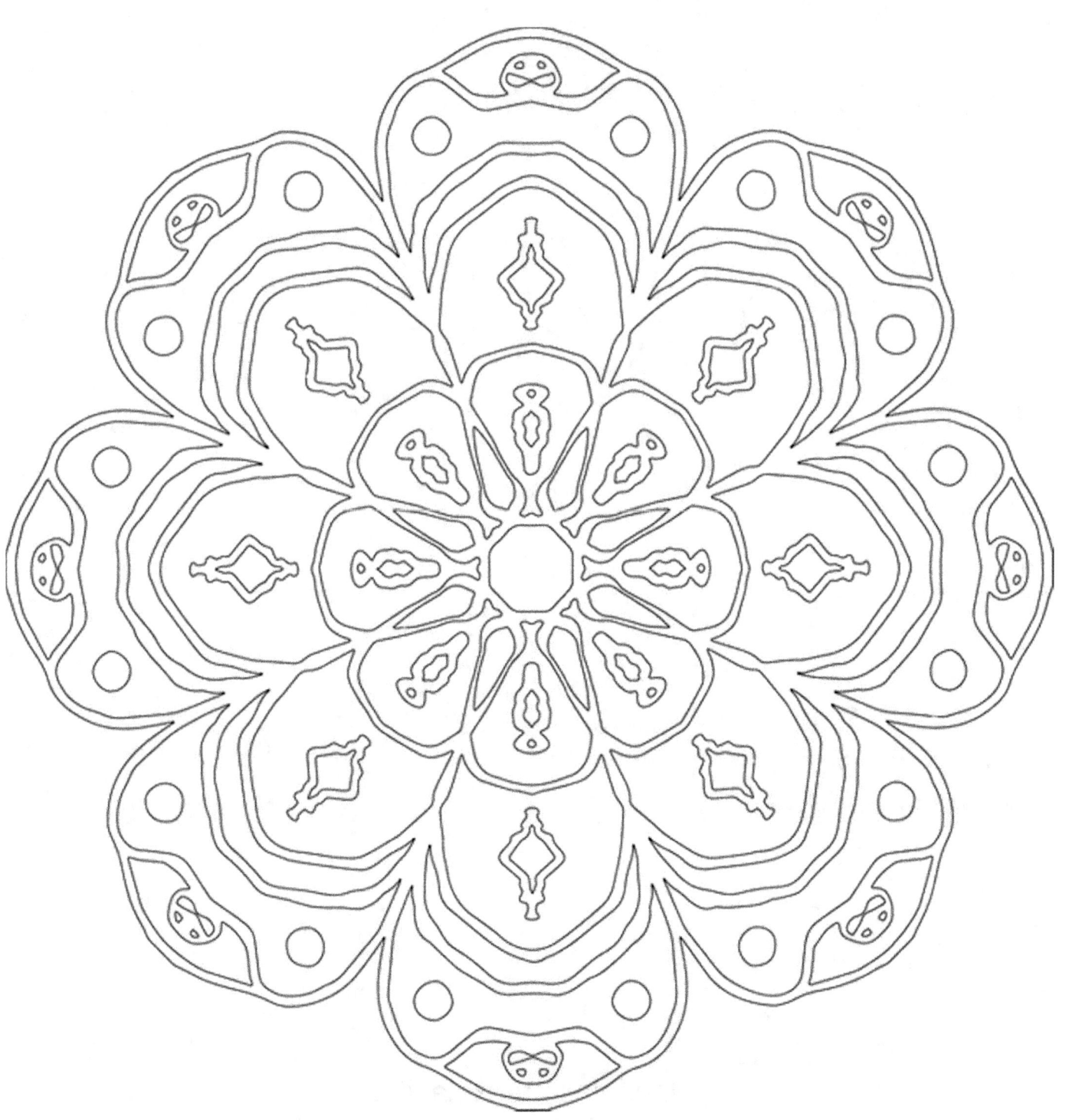

Mandalas are Relaxing

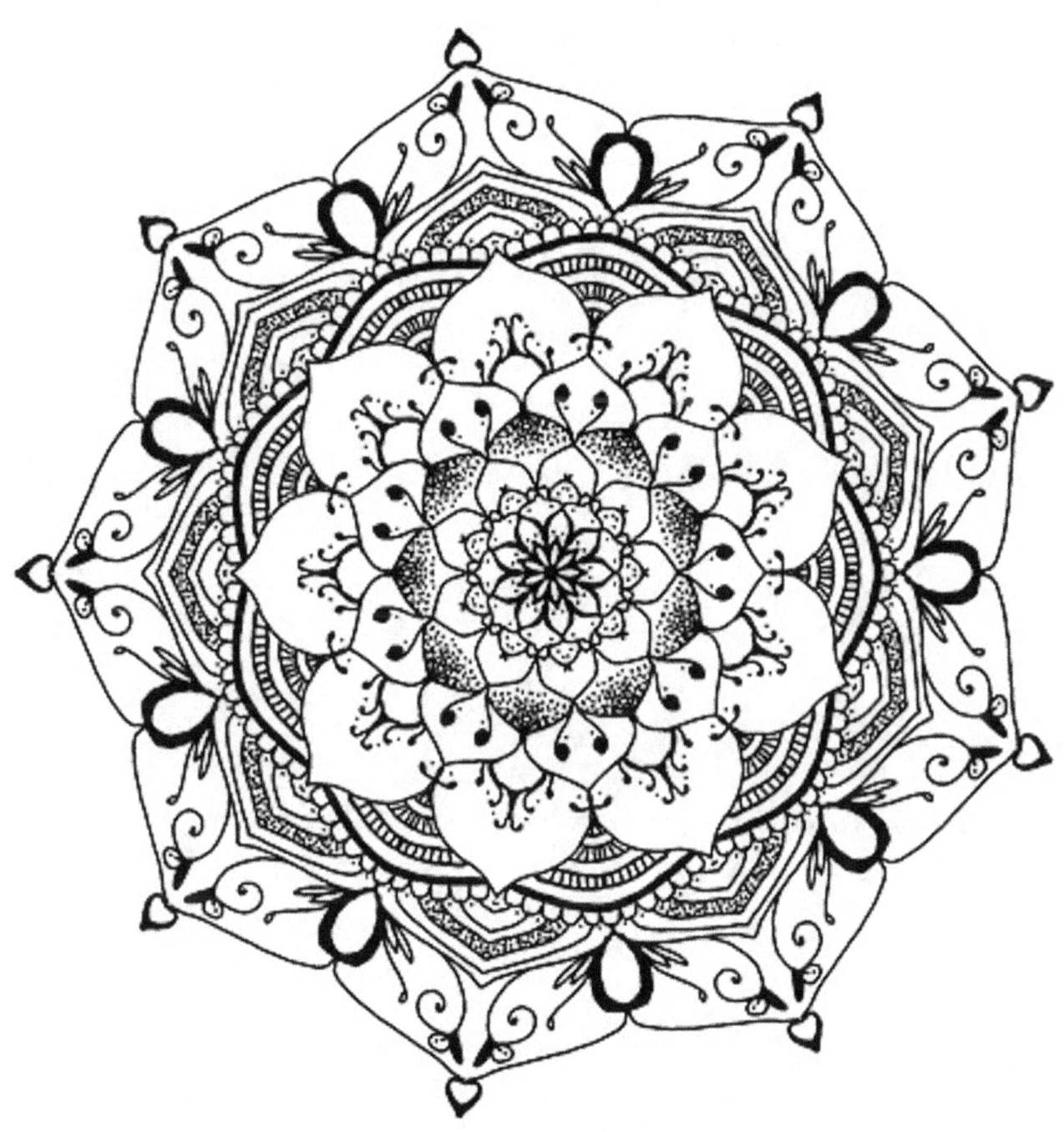

Mandalas are Relaxing

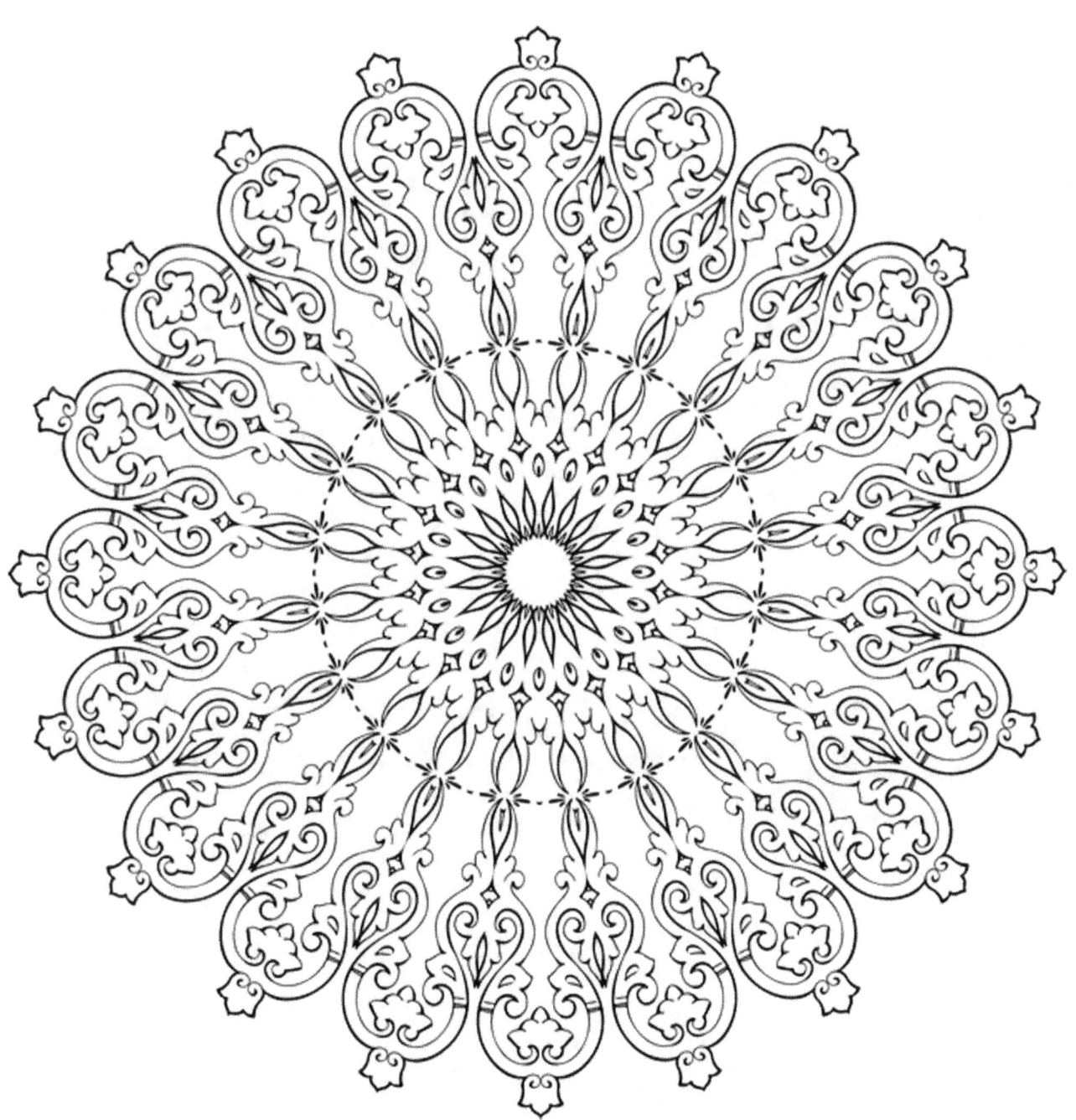

Mandalas are Relaxing

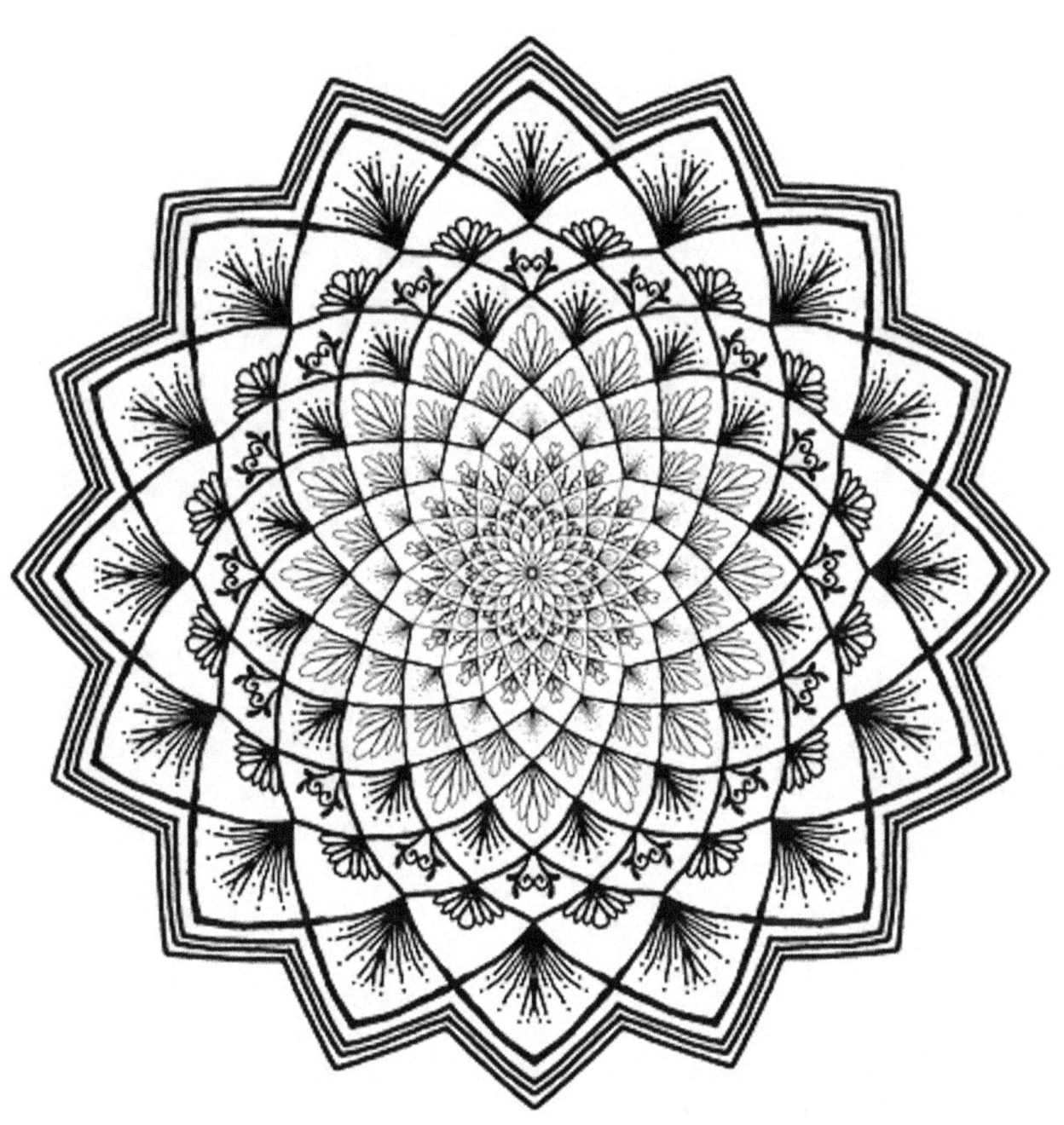

Mandalas are Relaxing

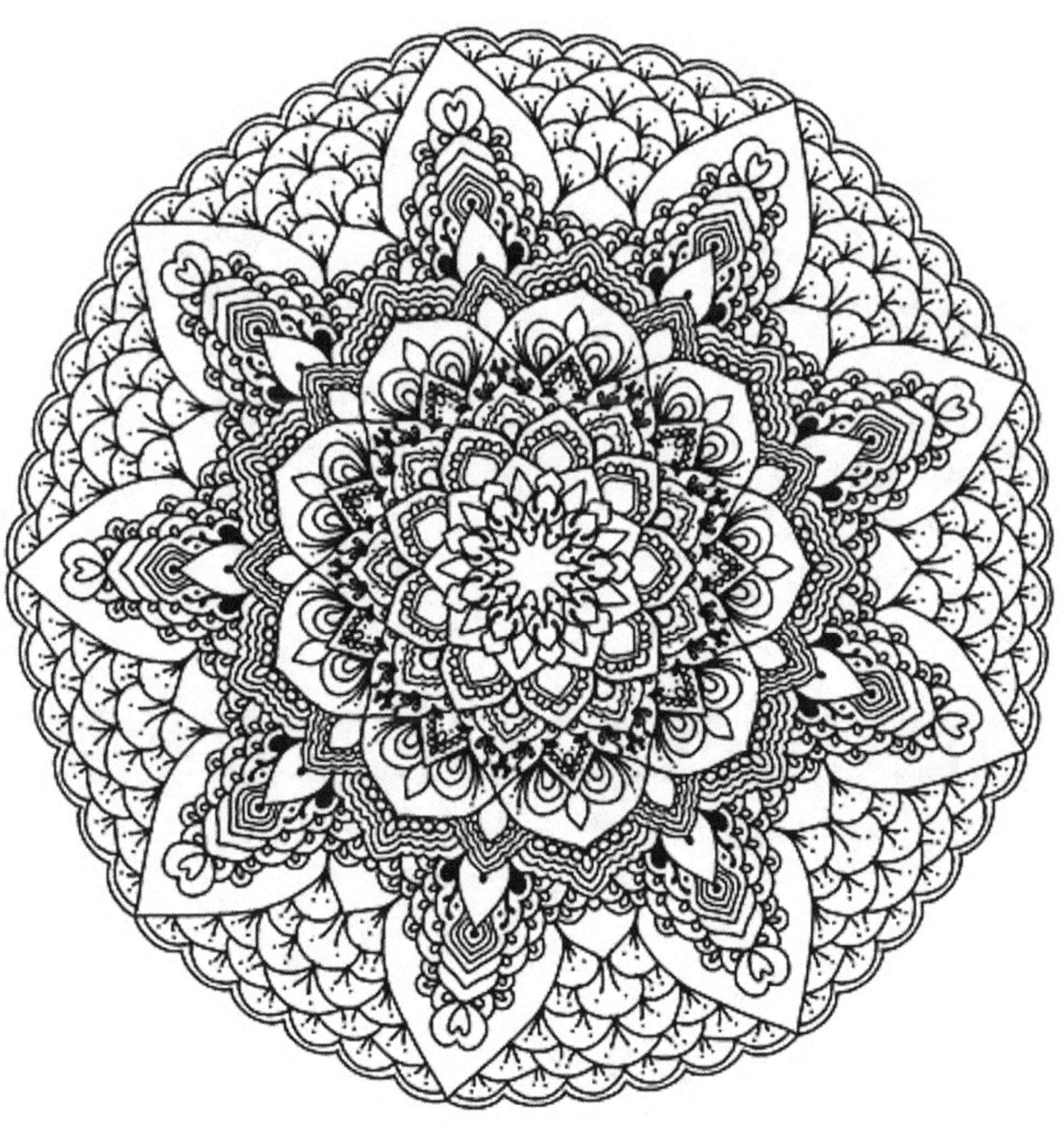

Mandalas are Relaxing

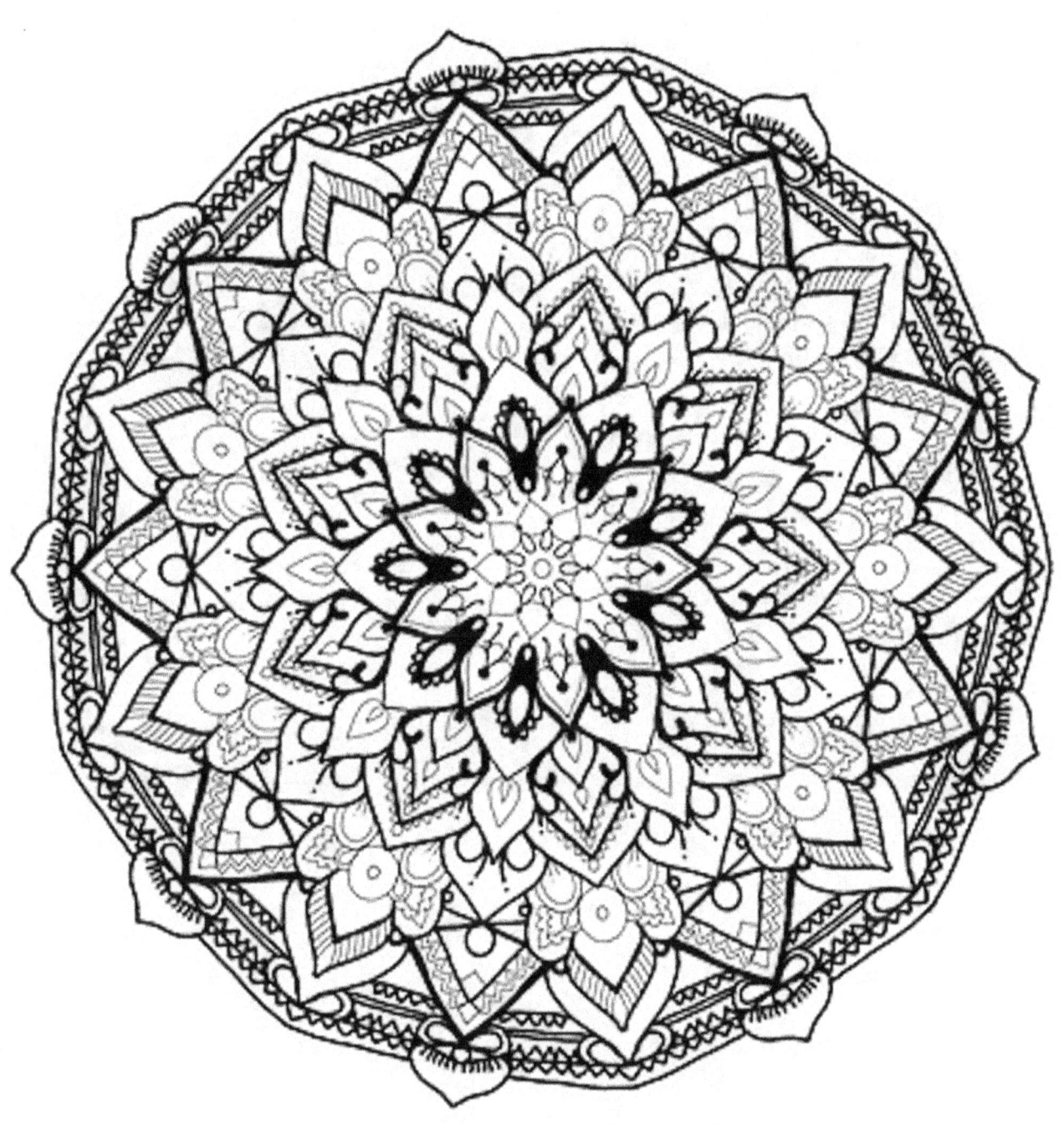

Mandalas are Relaxing

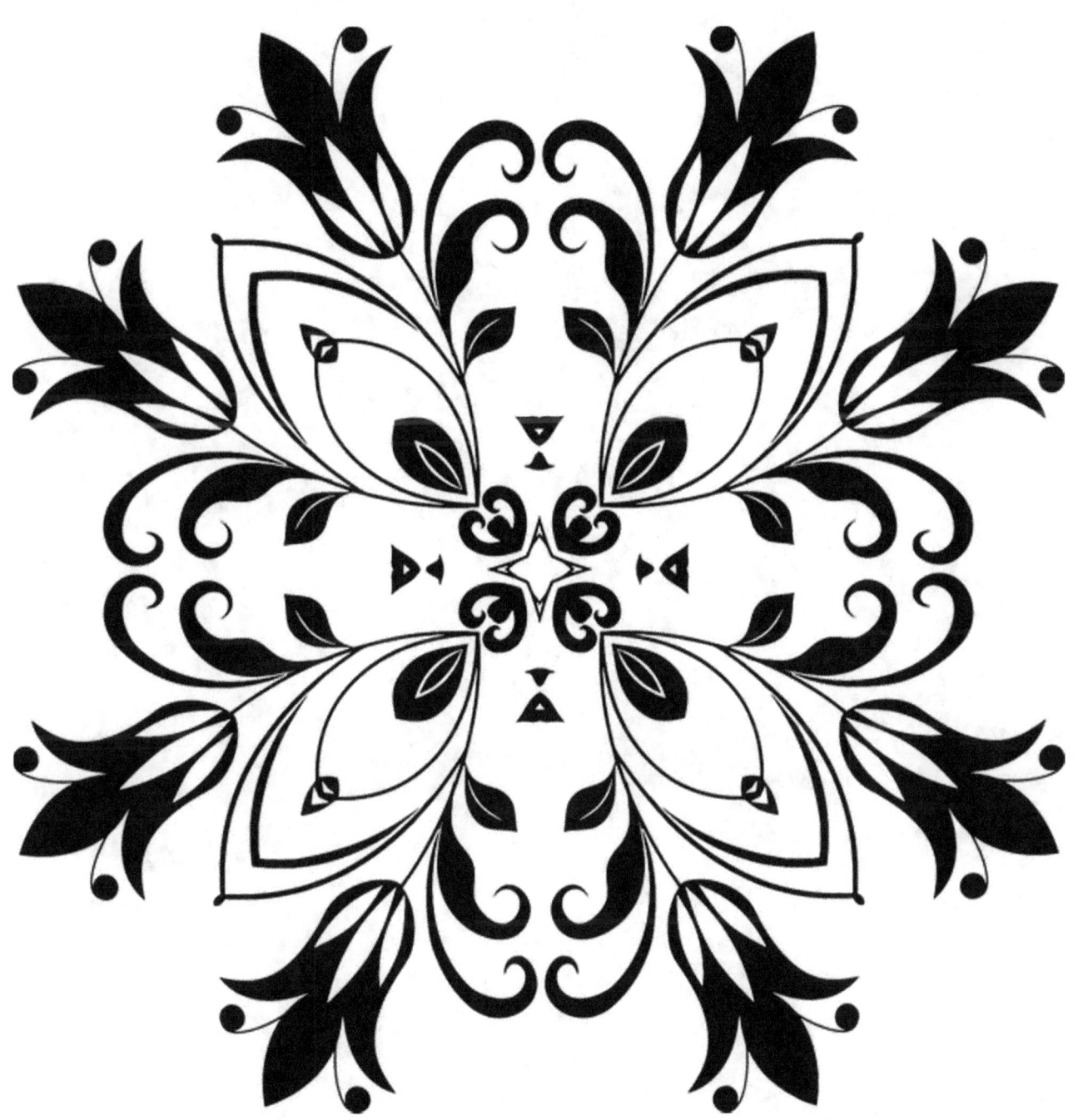

www.ingramcontent.com/pod-product-compliance
Lightning Source LLC
Chambersburg PA
CBHW080605220526
45466CB00010B/3253